To Wayne Day

Brave at Heart:

The Life and Lens of Atlanta Braves' Photographer Walter Victor

Walter J. Victor

Indigo Custom Publishing, LLC

Publisher	Henry S. Beers
Associate Publisher	Rick Nolte
Associate Publisher	Richard J. Hutto
Executive Vice President	Robert G. Aldrich
Operations Manager	Gary G. Pulliam
Editor-in-Chief	Joni Woolf
Art Director/Designer	Julianne Gleaton
Director of Marketing	Mary D. Robinson
and Public Relations	
Distribution & Fulfilment	Nick Malloy

© 2007 by Indigo Custom Publishing

Printed in China
Second Printing

Library of Congress Control Number: 2007922893
ISBN: 1-934144-12-6
ISBN (13 Digit): 978-1-934144-12-1

This book is edited to the Chicago Manual of Style.
Indigo custom books are available at quantity discounts with bulk purchase for educational, business, or sales promotional use. For information, please write to: Indigo Custom Publishing, SunTrust Bank Building, 435 Second Street, Suite 320, Macon, GA 31201, or call 866-311-9578. www.indigopublishing.com

The Life and Lens of Atlanta Braves' photographer Walter Victor, as told to Anne B. Jones and Sidney R. Jones

I dedicate this book to the memory of two
people who have had a profound impact
on my life:

General William C. Westmoreland

He served as a 9th Infantry Division Chief
of Staff during World War II and was a role
model for all of us.

Mr. Bill Lucas

As former Braves Vice President of Player
Personnel, Bill Lucas was one of the highest
ranking blacks in major league history.
At the time, Lucas was responsible for
establishing the Atlanta Braves' successful
minor league system and hiring me as official
Braves photographer.

I want to thank all of the fine people who helped me with this book. The Atlanta Braves organization, including all of the players, coaches, staff, and executives are truly my second family and I love them all.

I appreciate everyone who has given input and put up with me, especially my loving wife, Ruth, and all of our children, Ann-Margaret, Tony Van, Tommy, and Johnny.

Special thanks go to Furman Bisher, Bobby Cox, Skip Caray, John Smoltz, Terry Pendleton, Glenn Hubbard, Mark Lemke, Andruw Jones, Chipper Jones, Pat Corrales, Ray Cobb, Gary Caruso, Walter Banks, Chuck Dowdle, Adam Laroche, Glen Diamond, Joe Simpson, Leo Mazzone, Larry Hinson, Harlow Reynolds, Susan Abken, Bobbie Sanders, and "Butch" Nixon.

In baseball, you've got to be on guard for errors. It's the same for a book. Please forgive any I have made. I hope you enjoy it.

Walter Victor
Braves Photographer

What most of us know of Walter Victor is a man with a camera strung over his shoulder. His life story defines him as one whose theme-song might be, "Nobody Knows the Trouble I've Seen." That was the first part of his life. The second part has been just the reverse, a picture-book existence, so to speak. He is the mortar between the bricks of which this country is made. Somebody had to do it, so always, it seemed, Walter was there in the clutch. Coal miner, dress-maker, steel worker, gunsmith, and most impressive of all, a soldier before he turned to photography. My God, how he survived it all makes Private Ryan look like a tourist. Walter did it all in the style of the "GI Joe" cartoonist Bill Mauldin brought into all our lives, living from foxhole to foxhole. Walter campaigned through North Africa, Sicily, landed on the beach at Normandy, and spent months sloughing through the hedgerows of France into Germany, and survived the vicious scrimmage for the bridge at Remagen and the Battle of the Bulge. He can tell you what it was like to be talking one minute to a buddy sharing a foxhole, and then suddenly the buddy was gone. Shot dead by a sniper's bullet. He can tell you what it was like to go weeks without a bath, live on food you wouldn't give a dog, enduring every atrocity a soldier could stand and yet survive. He could tell you what it was like to hear General Patton in a rage. He can confirm that war is hell, and he has four Bronze Stars and eight Combat Ribbons to back him up. That was the worst half. Then the war ended and he came home to Ruth, and that was the beginning of the good times. Walter then began to record various versions of life around Atlanta. Some do it in words; he spells it out in pictures. Hardly a Braves game is played that Walter isn't on the scene. He skitters about like a cat chasing a ball of yarn. Snapping here, meeting and greeting, as much of old Atlanta Stadium then and Turner Field now as the sod. After what Walter went through on the battlefield, life owed him a good turn. Bill Lucas gave it to him when he appointed him official photographer of the Braves, but he hasn't limited his field of activity to the team that he loves. You'll see his handiwork all around town of various functions and other teams, but Walter, the guy, is my major interest here. If he's around, be at your best, for you never know when he's going to snap at you. One of my warmest moments with him was the night he was honored before a Braves game. The two of us, veterans of the Great War, shared a good hug, and somebody got a picture of it. One of the rare times Walter was in a picture, not taking it. I don't know what you're supposed to do when you write a foreword, or introduction to a book, but the best way to go about it, I'd guess, is to shoot from the heart. Walter has been doing that for lo, these many years. His parents were Polish, and I have no idea if Victor is his real name, or a translation, or an adaptation. All I can say is, it couldn't have been more appropriately applied to any human being, one of the Greatest Generation. —furman bisher

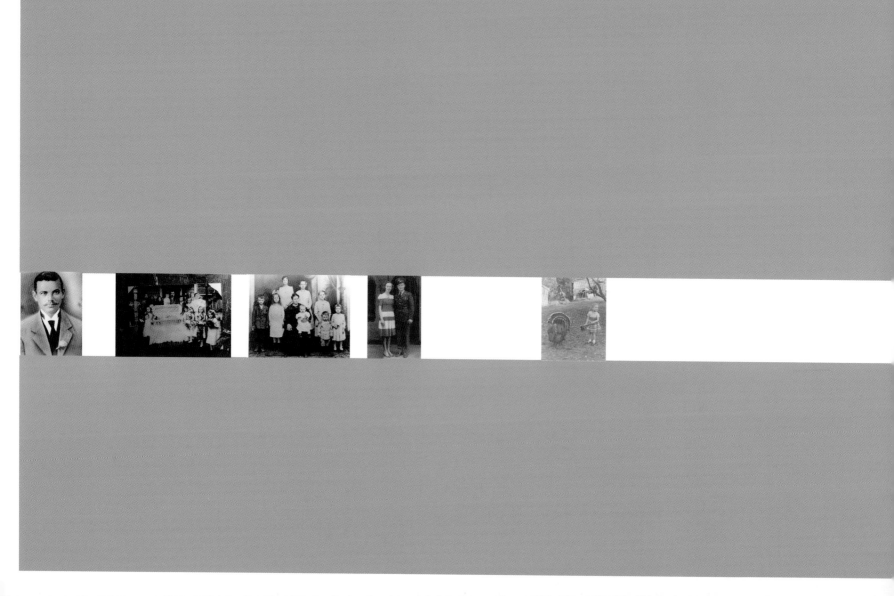

before the braves

I n 2004, the Atlanta Braves dedicated a pre-game ceremony to Braves photographer Walter Victor, honoring him with his own stadium camera well, bearing a brass plaque inscribed with his name. Referred to by Braves infielder Chipper Jones as a Braves icon, "Victor," as he is fondly called, has played an important a role in the Braves organization for forty years. Now in his Nineties, he still sees the world through the camera's lens, capturing and preserving Atlanta's baseball history.

Victor's awareness of the world and events around him was fostered at an early age. His survival depended on it. He was born and raised in Dupont, Pennsylvania, a tight-knit coal-mining community, deep in the heart of the Pocono Mountains. The town was located on the outskirts of Scranton, a city which had served as an early center for iron and steel manufacturing before becoming an industrial hub for the surrounding anthracite region. A high carbon, low-sulfur hard coal, anthracite was in high demand during the first of the twentieth century.

Its mining was dangerous but labor intensive, providing much of the employment for our nation's immigrants.

Victor's parents, Frank and Agnes, came to America from Krakava, Poland in the early 1900s, searching for a new world and a fresh start. Times had been hard in Europe and they couldn't find work. Sadly, the couple's dreams would be short-lived. Desperate to support his wife and eight children, Frank Victor became a coal miner.

The family knew the mine was dangerous but it was the center of their community, providing for their survival at the same time it could turn on them. Aware of the possibility of toxic fumes, lack of oxygen, cave-ins, and brown lung disease, their life became a struggle to survive filled with fear.

When Victor was two, his brother accidentally killed his sister, Josephine, with his father's rifle. Soon afterwards, on June, 4th, 1919, a tunnel in the Scranton mine collapsed burying Frank Victor alive.

The small pension the mine provided offered little financial support for the Victor family. Agnes, unable to make ends meet, was forced to put her children to work, and, although she was a devout Catholic, she turned their home into a distillery.

"She made whiskey in our basement," says Victor. "When I was older, she instructed me so I could help her. When each batch was ready, she poured it into small bottles

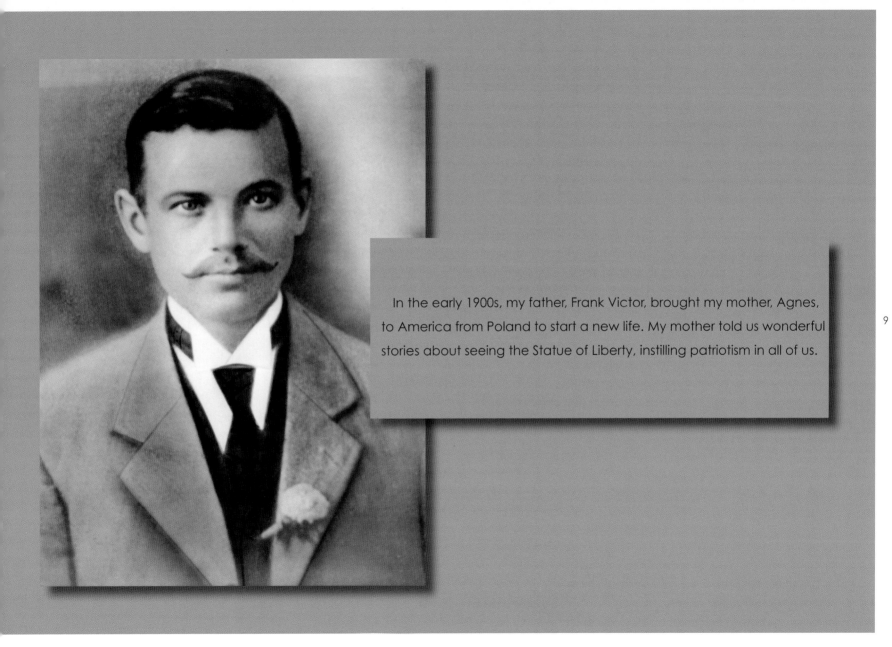

In the early 1900s, my father, Frank Victor, brought my mother, Agnes, to America from Poland to start a new life. My mother told us wonderful stories about seeing the Statue of Liberty, instilling patriotism in all of us.

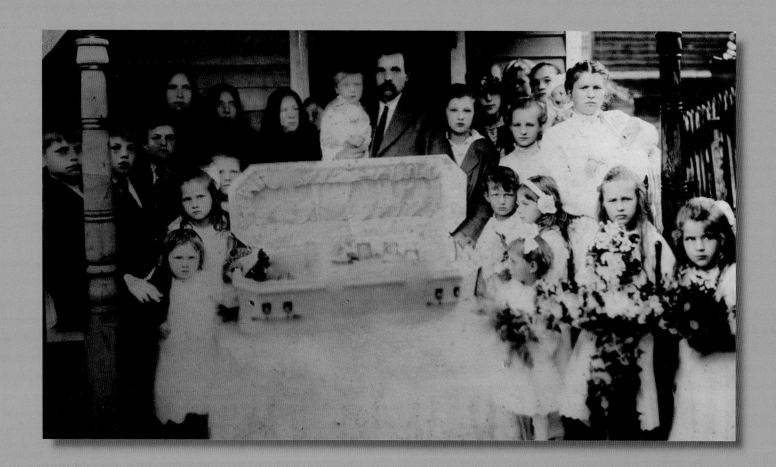

This picture was taken the day of my sister Josephine's funeral in early 1919. She was accidentally shot by my brother. My father, Frank, who would die a short time later, is holding me in his arms.

which she tied to a string around her waist. Because she was heavy, it was easy to hide them under her skirt. Although it was hard to walk with so much weight, she headed for the streets of Wilkes-Barre. When she had a customer, she'd just reach into her skirt and untie the string.

"In winter, we used the same coal my Daddy had mined to keep us from freezing. We lived in a small two-story home and my mother kept our cast iron stove going day and night. We couldn't afford new clothes and rarely had shoes. My brothers and sisters and I supplemented mother's moonshining by delivering milk and picking berries. On school days, I'd get up at 4:00 a.m. to deliver the milk. Sunday's were always special because we'd have chicken, although it was always my job to wring its neck.

"When school let out for summer I'd go camping in the mountains with my brothers and sisters and we'd gather as many berries as we could, always listening for bears and snakes. Sometimes, I would be picking on one side of a bush and see a bear on the other side, but he'd soon get tired and leave. If they saw us, they'd run away. One night, I was lying in our camp and felt something cold. I struck a match and saw a big rattle snake. The experience taught me to be vigilant and pay attention to my surroundings.

"When we had gathered as many berries as we could carry, we'd take them to town to sell and give our money to Mother. Our reward was always twenty-five cents. There wasn't much we could do with it, but we were glad to get it.

"One summer, my brother, John, and I became lost in the woods in a storm. John was so thirsty, he drank water from a swamp and then began vomiting. When we reached home we rushed him to the hospital where he was diagnosed with typhoid fever and almost died. We were so thankful when he came home, we put up welcome signs.

"When I was older, I spent my summers on a farm picking apples. Christmas became our favorite time, because it was the only day we didn't have to work. We'd hang stockings on Christmas Eve and the next day they were filled with fruit."

Ten years after his father's death, Agnes remarried. The children's stepfather was an increasingly abusive alcoholic, who constantly picked on Victor. When he was angry, he would grab the young boy by his hair and fling him under his bed. The couple had two children together, but after five years, Agnes could take no more of his violence and filed for divorce. Unable to provide for her family, she forced Victor to drop out of school and enter the mine. It was a painful time. At seventeen, he had been an excellent student and

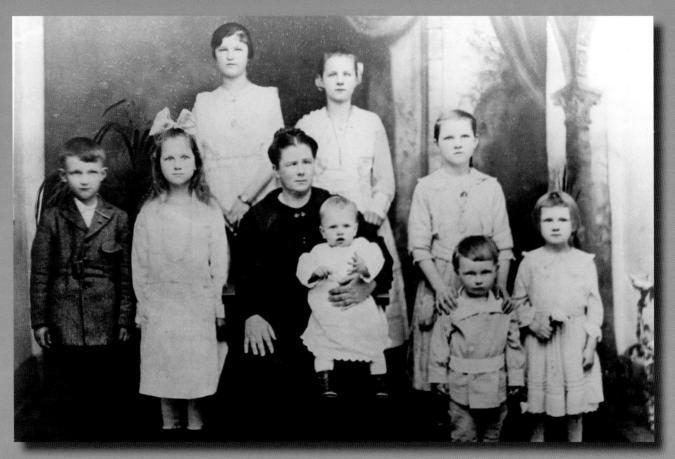

My mother and all of her children posed for this the day of my father Frank Victor's funeral. He was killed on June 4, 1919, when the Scranton mine in which he was working collapsed, burying him alive. (From left to right John, Caroline, Kay, my mother Agnes, Frank, Mary, Sally, me, and Anna).

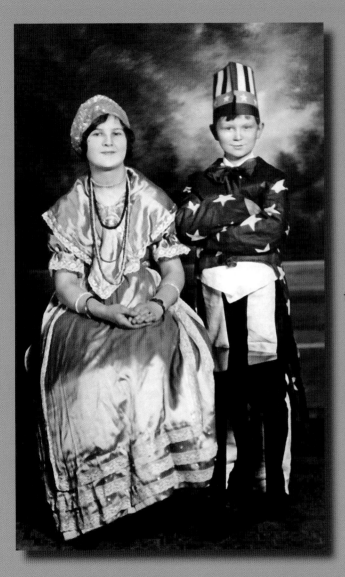

In this early photograph, with his sister, Sally, Walter is already wearing the stars and stripes, reflecting his early Patriotism.

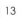

eager to learn. Forced to follow in his father's treacherous footsteps, he gave up the one hope in his life, an education.

"My days began early and lasted late and I had to remain alert. We'd been trained to watch rats and canaries. If rats were running, we knew there'd be a cave-in. If a canary died, there was gas and you'd better get out. I learned to tie my lunch to a string to prevent the rats from eating it. In the evenings I'd emerge black with coal dust, with a throbbing headache. When my cousin and I were almost killed by a dynamite blast, I made up my mind to escape."

With only the clothes on his back, Victor spent two days hitchhiking to New York to live with his sister. She was able to get him a job at a factory, cutting and sewing dresses. When he discovered those with imperfections were being thrown out, he persuaded his boss to let him have them. He mailed them along with part of his paycheck to his sisters back home.

After a few months, disappointed in the factory's low wages, Victor decided to apply for work at a steel mill.

"One thing I've always had in life is persistence. Every morning, before I'd go to the dress factory, I'd go to the steel mill and ask for employment. They got tired of seeing me come in and finally hired me just to get rid of me."

Beginning as a casual, he quickly moved up to permanent.

Because he had no car, he accepted an invitation to rent a room from his boss.

"He treated me as if I were part of his family, fed me lots of Italian food, and, for once in my life, I had free time. Because I had never had the chance to participate in sports, when I saw the YMCA was offering boxing lessons I took them."

Victor's new life was pleasant and comfortable, but short-lived. World War II was raging and at age twenty-two, he was drafted. Assigned to Fort Bragg, North Carolina, he began basic training in firearms repair. The regimen was physically and emotionally demanding. Sometimes walking twenty miles in the rain, the draftees would return at midnight and then get up at 5:00 a.m. to go to the shooting range. Since his mother and sisters were still struggling back home, he continued to mail most of his paycheck to them.

Free time was rare, but when they had a few extra hours, the new inductees divided into teams and played baseball. Although he had never played before, Victor became a good pitcher and the games sparked an interest that stayed. Afterwards, he kept up with the major league teams whenever he could.

While he was at Fort Bragg, Victor decided he needed a car. There was a shortage due to the war, so he asked his brother-in-law who lived in Chicago to look for one. When

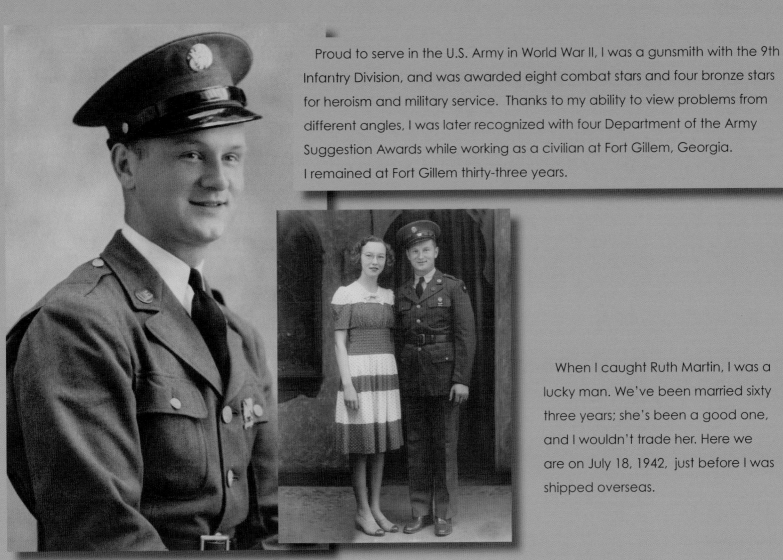

Proud to serve in the U.S. Army in World War II, I was a gunsmith with the 9th Infantry Division, and was awarded eight combat stars and four bronze stars for heroism and military service. Thanks to my ability to view problems from different angles, I was later recognized with four Department of the Army Suggestion Awards while working as a civilian at Fort Gillem, Georgia. I remained at Fort Gillem thirty-three years.

When I caught Ruth Martin, I was a lucky man. We've been married sixty three years; she's been a good one, and I wouldn't trade her. Here we are on July 18, 1942, just before I was shipped overseas.

Because I was a gunsmith, I was always on the front lines. I could be talking to a young man one minute and the next minute, the Germans would get him. Here I'm fixing a soldier's weapon a short time before he was killed.

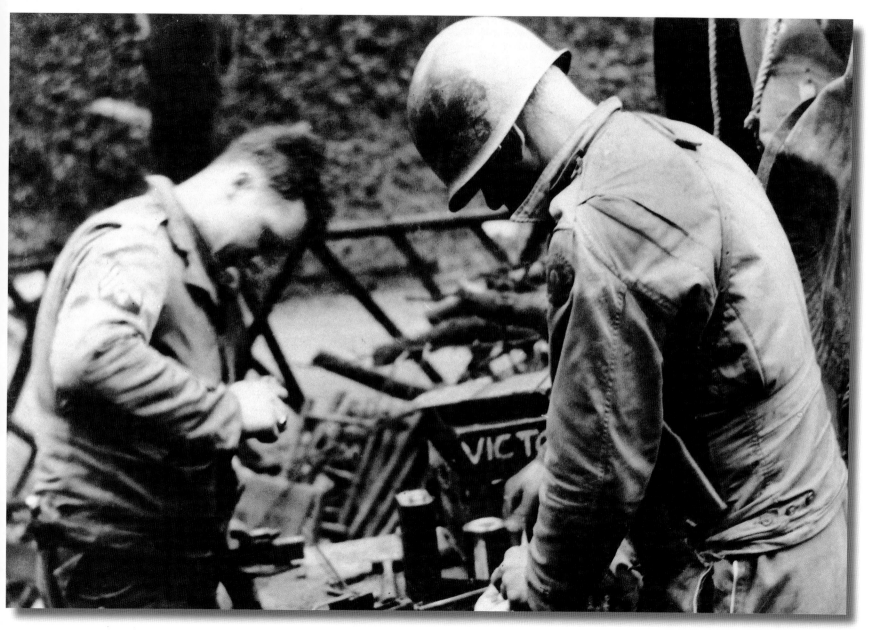

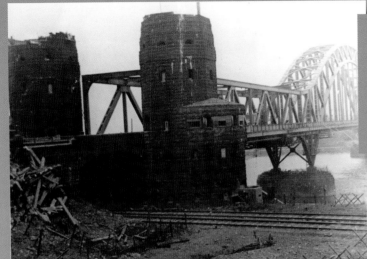

I saw German jets for the first time at Remagen Bridge. They were so fast our guns couldn't hit them. The bridge was strategically important in World War II because it crossed the Rhine River between France and Germany. We made it across just before it collapsed.

This picture shows the Remagen Bridge after its collapse. The Germans wanted to destroy it as determinedly as we wanted to preserve it. Former Braves pitcher Warren Spahn served as an engineer at the Remagen Bridge during World War II. He played for the Boston Braves before and after the war, and went with them to Milwaukee. With his high leg kick as a trademark, 'Spahnnie' was called the 'Invincible One.' He was one of the greatest left-handers in history, but I admire him most for his work on the Bridge.

U.S. Army Photographs

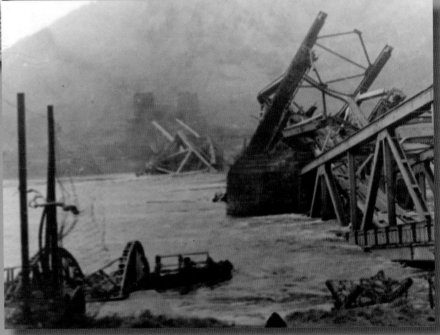

he found a used Plymouth, Victor rode a bus to Chicago to get it, and then took it back to the base.

"I earned gas money by charging other soldiers for rides. Because gas was rationed, I put in an extra tank so I wouldn't worry about running out."

On one of his outings, Victor went to Chadbourn, North Carolina and stopped at a store to shop. It was there he met his future wife, Ruth Martin.

"She was working in Woods Five and Dime. When I went in, she stopped what she was doing to chat and we talked for three hours. She was only sixteen, but she was good looking and a good talker. It was love at first sight."

Before their conversation ended, Ruth invited him home to meet her parents. "I loved to hear her voice with her sweet Southern drawl. Her family lived in the country and raised tobacco and melons. They showed me how to cure tobacco and offered me some yellow watermelon. It tasted so sweet. To this day I love yellow watermelon."

Enamored with the pretty Southern belle, Victor went back to visit each time he got a pass. Ruth had a boyfriend, but soon broke up with him, unable to resist the charms of her determined suitor.

"One day, we went to Dillon, South Carolina. Ruth told me it was the town where her mother and father had married. I turned to her and asked if she would marry me. When she said yes, I felt like I was on top of the world."

Victor's mother, Agnes, wasn't pleased with her youngest son's decision. Steadfast in her loyalty to old-country cultural traditions, she at first rejected the girl, who was neither Polish nor Catholic. Years would pass before she finally accepted her. When Ruth visited her the last time before she died, she put her hands on each side of Ruth's face. Looking her straight in the eyes, she said "You are truly my daughter."

The couple was married only one month when Victor received his orders to go overseas. Because he was mechanically inclined and trained as a gunsmith, he was assigned to the 9th Infantry Division. Known as the "Old Reliables," the men would stay in the heart of the fighting. Longing for his new bride, Victor wrote letters to Ruth every other day.

At twenty-two, Victor's life had been hard but nothing could have prepared him for what was to come. He would serve in Algeria, French Morocco, Sicily, Tunisia, and England before advancing through Northern France, Ardennes, Belgium, the Rhineland, Germany, and Central Europe. Before the end of the war, the 9th Infantry Division would

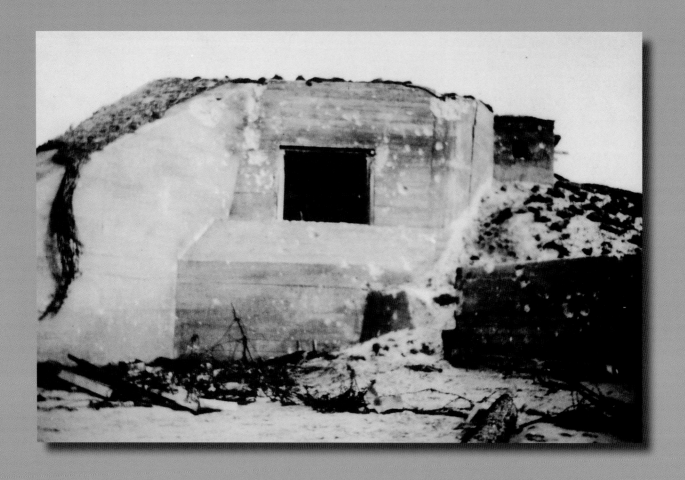

This is a typical German 'pillbox,' or machine gun post, captured by the 9th Infantry Division as we marched through Europe during the latter part of World War II.

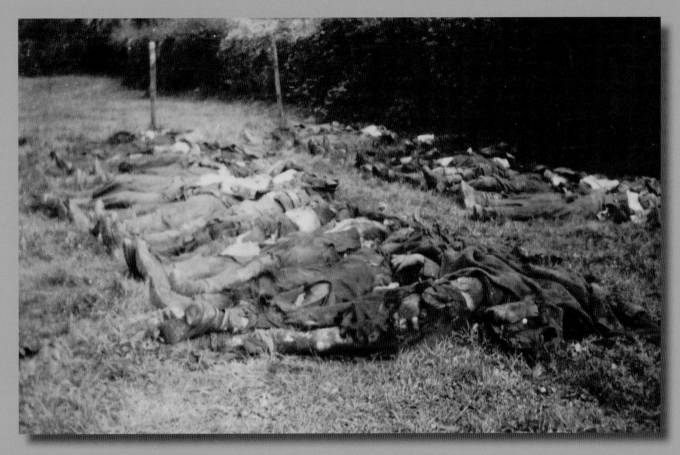

The German concentration camp called Dachau was liberated in 1945 and what we saw was incomprehensible. The prisoners who survived were skin and bones and too terrified to speak. How can human beings treat other human beings so cruelly? Thinking about it brings tears to my eyes and I still have nightmares.

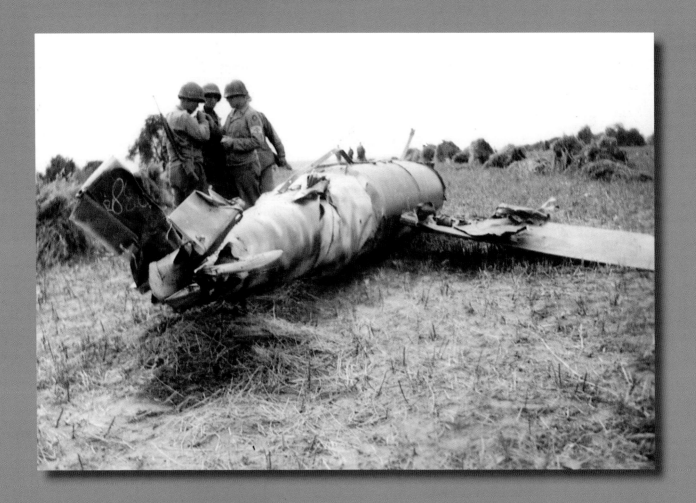

G.I.s examine the remains of a German V-1 rocket.

suffer 16,561 wounded, 4,581 deaths, and 750 missing in action. They would participate in the most violent battles of the European theater and take 130,000 prisoners of war.

"On the day we were to leave for Norfolk, Virginia, we were given a pep talk by General Patton. He used so many cuss words the commissioned officers' wives had a fit. We traveled by train to Norfolk and I'll never forget the sign I saw when we arrived downtown. It said 'Soldiers and Dogs Keep off the Grass.' I felt like someone had slapped me. Norfolk was a military town, but I felt unwelcome.

"Within a few days, our unit was shipped out. We moved in a convoy made up of destroyers, submarines, and troop ships. For thirty-eight days, we tried to outmaneuver German torpedoes. Some of our ships were hit and I could see people swimming. We used depth charges against the enemy submarines as we picked up survivors."

Haunted by the accidental shooting death of his sister, and wanting to keep busy, Victor taught the ship's sailors to clean and repair their weapons.

"I gave lessons to the sailors on fixing their guns and showed them how to dismantle them blindfolded. The day before we landed, the captain sent two sailors to escort me to his cabin. He said he appreciated what I'd done and invited me to dinner. It was quite an honor and was one of the nicest dinners I have ever eaten.

"When we arrived in North Africa, a sailor let down the plank and the chain caught his hand, breaking his arm. We got into landing crafts and I noticed the soldier next to me was so frightened he was shaking. We hit the beach near Casablanca and met a lot of resistance from the French Foreign Legion. They were rough but they quit fighting when they found out we were Americans and we toasted each other with wine. They didn't drink water; they just drank wine. I got along with them well because some spoke Polish."

Within a few days, the troops were banding together to invade Morocco. Victor served as a sniper and participated in the battle at Kasserine Pass.

"Every morning, the French anthem was played at 5:00 and we watched the French soldiers use straight razors to shave their faces and heads. We had to learn a lot about different cultures during the war. It was important because if we didn't, we might do the wrong thing.

"We lost a lot of our buddies on the African coast. After we buried them, we headed for the Atlas Mountains toward Sicily with a British division. The British had a custom of stopping for tea but it wasn't wise. When they stopped

to have their tea, they were bombed by the Germans.

"The terrain was rough and it rained every day. Climbing the mountain was slow and hard. We used mules to carry our supplies but had trouble getting them to move. We solved the problem with a big wallop using a two by four. The British didn't fare much better. Equipped with two wheel drive vehicles, they were continually bogged down in the mud. We spent most of our time helping them out.

"Our men didn't know it, but while we were in Africa, we were preparing to go to Sicily. We trained in the Sahara Desert in 134 degree heat and it was so hot we only wore underwear. I was bitten seven times by large scorpions and, oh, how it hurt. The eighth time, the medic told me since I hadn't died to just go on back to my outfit, I must be immune to them.

"One of the most impressive people I saw in Africa was General Patton. I remembered his farewell pep talk, and no, he had not stopped his cussing. He came charging through, calling us bastards and told us to get out of the way of his tanks. When he was made to apologize for slapping a soldier, it was to one of my buddies. He'd been so shell-shocked he hadn't responded to one of Patton's orders.

"Because of my knowledge of guns, I was repeatedly sent to the front lines, and came under friendly and enemy fire.

Sometimes it was hard for us to tell our men from the enemy.

"The hardest part of the fighting was losing my friends. I would be talking to a young boy one minute and the next minute a sniper would get him. Because I was a sharpshooter, I was often assigned to sentry duty. While serving as a lookout at the top of a hill, I saw an Arab robbing the body of one of our soldiers. The thief had seen him reading a telegram and thought he had money. I became so angry I shot him with my M-1 rifle as he was running away. I hit him in the forehead with my first shot, killing him right there. When I reached the soldier, I found him holding the telegram in his right hand, announcing the birth of his son.

"Our division was still in Africa when we learned we were about to be overrun by Rommel and had to evacuate. We burned our remaining planes by placing incendiary bombs on their engines. I had a funny feeling destroying our own equipment but we had to keep the Germans from getting them. Before leaving, I went into a building we had used and stuffed two grenades down the flue of a pot bellied stove. I knew if it were lighted, they would explode. Later, when we returned I found the stove in pieces.

"Once we came under fire from sixteen German dive bombers. I was about to jump into my foxhole, when another

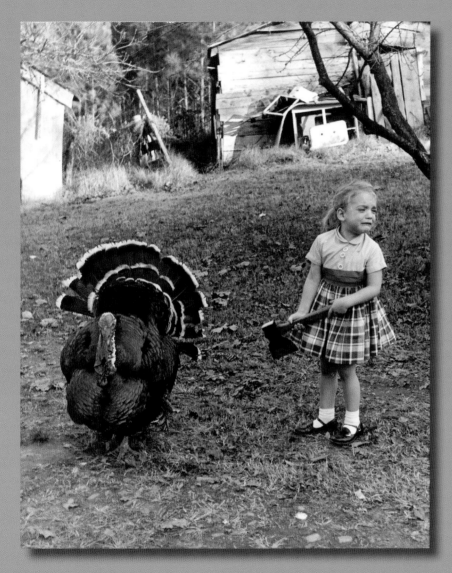

In 1955, this Thanksgiving picture of little Ginger Martin and her turkey was picked up by the Associated Press and circulated all over the world. It was my first famous photograph.

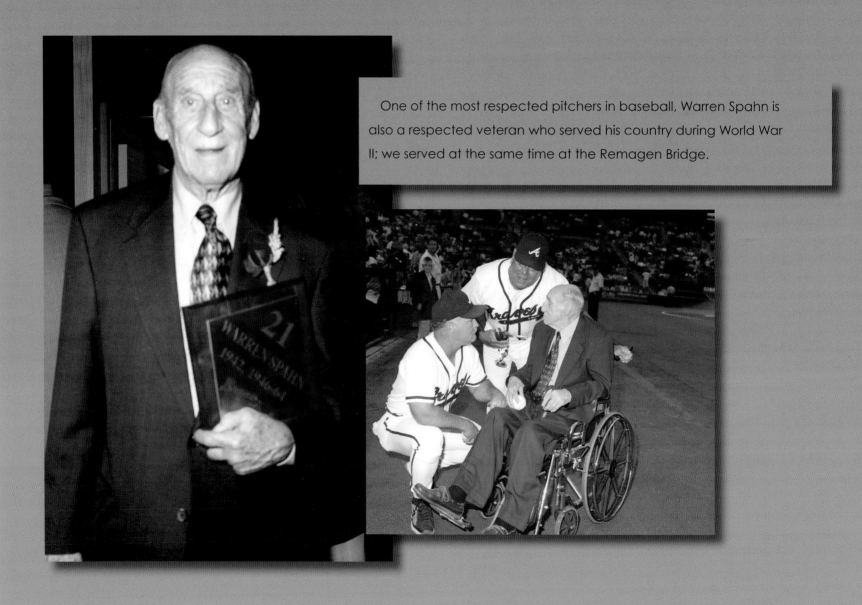

One of the most respected pitchers in baseball, Warren Spahn is also a respected veteran who served his country during World War II; we served at the same time at the Remagen Bridge.

soldier beat me to it. He received a direct hit. As he lay dying, he bled all over me. When the medics came, they saw the blood and tried to help me. They said I was going to get a purple heart. I told them, 'No, I don't want it, help my buddy,' but it was too late. Finally, British spitfires got after the Germans and they had a dogfight. The British downed fifteen of the German planes. It was a terrifying sight to see."

Thankful to still be alive, Victor picked shrapnel from his arms for weeks.

Walter's division was next transferred to Palermo, Sicily.

"When we got on the ship, we thought we were going home. Our unit had a little band and they played "Down Yonder" over and over. I heard it so often I began to love it.

"It was nighttime when we reached the shore at Palermo, but as we were landing, we could see torpedoes going by. As soon as I got off the ship, it was hit by a German aircraft and sunk, with men still aboard. Because the Sicilian people didn't have water, our engineers drilled holes in dry creek beds to make wells. I saw a lot of dead bodies that were not soldiers and wondered why. We found out the catacombs had been bombed. People explained that was where they preserved bodies before burial by hanging them to dry.

"The people were friendly and the scenery was beautiful but the best thing about the Sicilian people was their food. They knew how to cook spaghetti and the sauce was wonderful. Compared to army rations, it was a gourmet meal. I was used to just eating Spam."

Because they weren't constantly fighting, Victor took time to explore the countryside. He drove up the side of Mt. Etna, but came back with flat tires.

"The worst thing about being in Sicily was we were supposed to take special pills to ward off disease. Because we didn't have any, I got malaria."

After so many months of combat, the men boarded ship to leave, and again, thought they were heading home. Instead, they went to Winchester, England, unaware they were starting their training for the D-Day invasion.

They were in England for six months, during the time in which the Germans were bombing London.

"There was confusion among the men because the 220 voltage was different and there were a lot of wrecks, because cars' steering was on the opposite side."

While he was there Victor got a pass to London and bought his first bike. "I'd never ridden a bicycle before and I was a sight, but I also had my own jeep. My pass

was unrestricted because I fixed guns for all of the troops, so I often found my way to 'fish and chips'."

Because he was such a good shot, he used his free time to hunt Ringneck Pheasant to take back to the men.

"Every morning, my buddies gave me a list of how many they wanted. I never killed the females, but I'd rip off all the males' feathers while they were still warm.

"One night, I got a pass to London and rented an upstairs room. I was hungry, so I went back out to get something to eat. When I returned, I found an incendiary bomb that hadn't gone off, had crashed through my bed."

Unaware of the reason they were in special training, Victor and the men were puzzled by the unusual military maneuvers they saw.

"Everyday, we watched men go up in gliders pulled by C-47s and didn't know why." Later, when their training ended, the 9th Division was told to get rid of their belongings. When he learned his brother, Frank, who was in the 28th division, was stationed nearby in Wales, he contacted him. When Frank came to visit, he gave him his bike.

Finally, the men were alerted as to their mission. The division was put on another ship, headed for the D-Day invasion.

"We landed on a patch of shoreline, code-named Utah Beach. The spot was chosen because the allies needed a major port, and the area was close to Cherbourg. Some of the tanks transporting troops to shore were supposed to be waterproof, but they were not. The most sickening sight was watching them sink with their hatches down and men trapped inside. It's something I'll never forget.

"Machine guns were waiting for us and killed our men left and right. So many were shot, the ocean ran red with blood. Because the water was so deep, many of my comrades drowned from the weight of their packs. We were instructed not to help anyone because if we were distracted, the invasion would fail. We were terrified, and held our rifles over our heads as we moved toward shore.

"The sky was full of gliders, but the Germans planted poles in the fields to snag them. When the gliders came down they hit the poles and split on impact. We were in a farming area and the pastures were covered with bodies of soldiers and cows. So many died, so many kids. You'd be talking to them, and then the Germans would get them and they were gone."

No words could describe what the 9th Infantry Division encountered, lack of food and water, freezing temperatures, rough and flooded terrain, and the constant threat of enemy fire. Most of their time was spent in small cramped trenches,

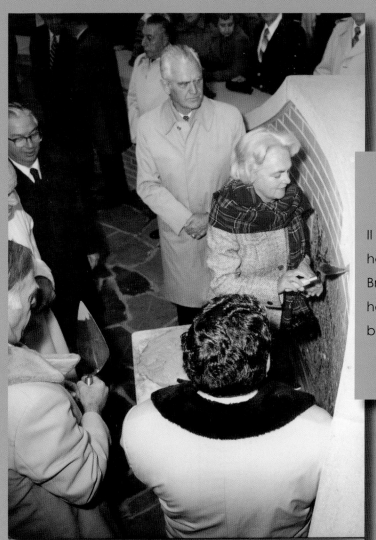

General Westmoreland and his wife are shown at the World War II Memorial in Washington, D. C. During World War II, Westmoreland helped the 9th Armored Division to hold on to the Remagen Bridge, spanning the Rhine between France and Germany. Later, he was put in charge of the U.S. war effort in Vietnam, before becoming the Army's Chief of Staff.

For our fiftieth anniversary, Ruth and I rented a hall in a Catholic Church and had a Polish band where we danced the polka over and over again.

with the constant danger of frostbite when it was cold.

"The conditions were horrid and the smell was awful. Most of us suffered from chronic battle fatigue. We went without food for days, but I was not hungry. I was too worried about being shot.

"We couldn't change clothes or bathe so we went for months in our same uniforms, brushing our teeth with canteen water and dampening rags to wipe ourselves. The first thing we'd do when we returned to our outfit was ask for new uniforms.

"When we reached the first town, I saw paratroopers hanging from church steeples, shot by SS troopers before they could reach the ground. We fought our way through France, Belgium, and Germany. The French people were not friendly to us but the Belgians were kind. Once when I was sleeping in an open field, I was awakened by a thud. The next morning, I found an unexploded V-1 bomb beside my head. Two weeks later, we captured a factory in tunnels deep in the mountains. The Germans had been forcing Polish prisoners to make the bombs. Some of the people working there hadn't seen daylight in over two years.

"I told a Polish scientist about the undetonated bomb I'd found in my trench. He said the Germans thought all of the workers were 'dumb pollocks'. To show them who were the smartest, he'd twisted the wires on the bomb so it wouldn't go off. I gave that man candy and cigarettes. He'd saved my life."

According to Victor, the men of the 9th Division became bonded in brotherhood focused on their desire to survive. What they went through was incomprehensible to those who weren't there. The most heartrending experiences were seeing their buddies killed, and hearing the sounds of their agony.

"The German Storm Troopers mowed our men down one after another, and left them to die in the streets. I never knew if I'd be next. When I repaired a soldier's gun, I'd give it back and say, 'Go get 'em!'"

While Victor was in the midst of fighting, the Chief of Staff came by.

"He told me if I would take him to the front lines without him getting hurt, he'd have me a job when I got back to the states. I thought he was kidding, but I got him there safely and he insisted on giving me his name which I kept it in my pocket. After the war, he made good on his promise."

Victor's brother Frank's 28th Division was also on the frontlines. One day he came to see him. Later, Victor made up his mind to go to his brother. Not recognizing him at first, the guards began firing.

"That night, the men built a fire. I told them to put it out because 'Bedtime Charlie' would come by and bomb

them. They didn't listen, and sure enough, the Germans flew by, bombing and strafing the camp. I was so angry I told the sergeant he'd almost had us killed. After seeing my brother, I left. I didn't see or hear from him again until we were both back home."

While marching through the countryside, the soldiers slept on the ground protected only by sleeping bags. They zipped them up over their heads to keep rain and snow out.

"One day, a soldier came to me, saying there was something wrong with his gun. Before he gave it to me, he placed the handle on the ground, forgetting to take the clip out. The gun fired fifteen shots, and tore him in half, showering me with his blood. I'll never get over that experience. When I fixed the spring on the gun I had to give it to another soldier who needed it."

Later, two MPs came after Victor for a secret mission. Known for his determination and dependability, and his fluency in four foreign languages, they took him into Cherbourg, Belgium to run a mortar factory.

"One of the reasons I was chosen was because I could communicate. There were two-hundred civilians working under me who had been forced to work by the Germans. I had to oversee all operations, including the payroll. I wanted everything to be perfect. I worked there every day for six months inspecting each mortar. The last thing I wanted to happen was to have an American soldier try to use it and have it not work. Whatever I did, I wanted to do well. Our lives were depending on it.

"When the mortars were ready, I stamped them and delivered them to our front lines. It was scary but our men were sure glad to see me. Once I got lost in the dark and didn't remember the password. I asked the boys in artillery if I could spend the night and they told me where I could lie down. The next morning I woke up in front of a 155 mm gun. That got me going in a hurry."

Part of Victor's philosophy is to treat people with kindness and he was always good to the factory's workers. During Thanksgiving, one of the men, wanting to show his appreciation, invited him to dinner. The family was insistent that their guest eat first and the food was delicious.

"It was a great meal. The meat and vegetables were tasty and tender. My host was Czechoslovakian and I understood his language, so after we ate, we went out onto his porch to sit and talk. I was commenting on the good meal when I saw a dog's head in a bucket. I said 'Look at that!'

"He said 'Yes, that was your supper.' It made me so sick I vomited.

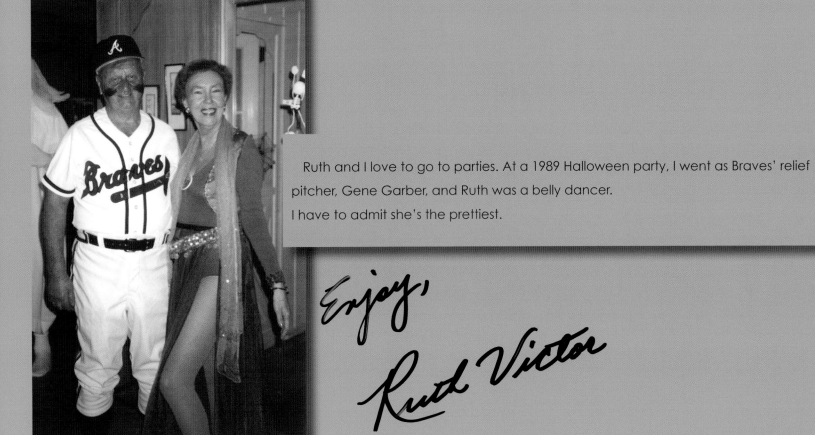

Ruth and I love to go to parties. At a 1989 Halloween party, I went as Braves' relief pitcher, Gene Garber, and Ruth was a belly dancer.

I have to admit she's the prettiest.

33

Enjoy,

Ruth Victor

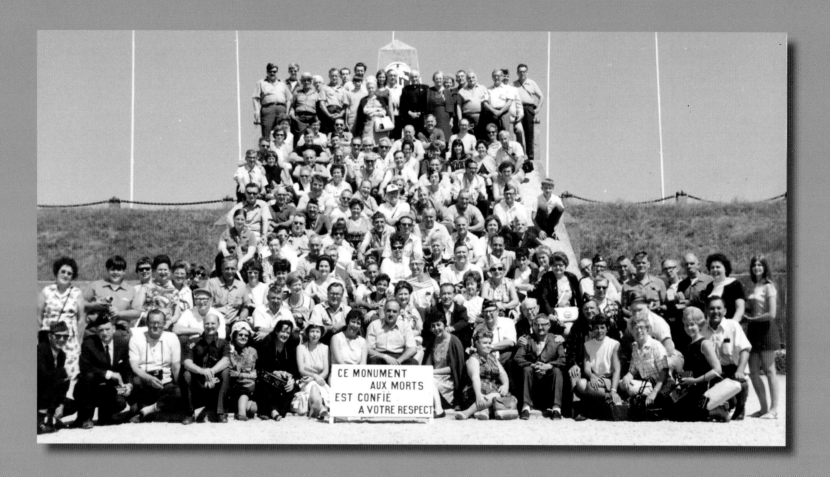

CE MONUMENT
AUX MORTS
EST CONFIÉ
A VOTRE RESPECT

On July 31, 1970, our 9th Infantry Division's twenty-fifth anniversary reunion was held on Utah Beach in Normandy, where we landed on D-Day.

"One time I was captured and put in a prisoner of war camp. I wasn't there long because I slipped out through a tunnel and found my way back to American lines. Knowing our division was marching into the camp, I began collecting candy, cigarettes, and chewing gum. Later, I gave them out to the prisoners who were so glad to see me, they hugged me. They were happy I was safe and had not forgotten them."

Because he was an expert in firearms repair, Victor was given a jeep and a pass to go anywhere. If a soldier was having trouble with his weapon he could get there fast and since they were dependent upon his expertise, other soldiers looked after him.

"Everywhere I went I had a man guarding me. Once when I stopped to eat, someone stole my jeep. It was easily recognizable because of its damaged headlight. A couple of days later I saw it being driven by two soldiers. I told my buddy who was in another jeep to go with me and we ran it off the road.

"Although they were dressed in American uniforms, the men in my jeep didn't look like our soldiers. I asked them if they knew where Yankee Stadium was and when they said New Jersey, with a German accent, I knew they were spies. I took my 45 pistol out of its holster and told them I'd kill them if they moved, then I held my gun on them while my friend went for help. Three days later they were executed by a firing squad."

"During the winter, the German soldiers dressed in white. We were easily seen in our khaki uniforms so a lot of our boys were shot. Shells from the German planes exploded ten feet over our heads. While we were fighting, General Eisenhower passed by. He noticed my shoes were wet and worn and asked if I had another pair. When I said no, he promised me new ones. The next day I got them. He had compassion for our troops and I'll always remember him."

"Our troops had compassion for others, too. We had a chaplain in our division, named Father O'Conner who was always broke. Right after payday, he still had no money. We couldn't figure out what was going on. Later we learned he was giving all of his earnings to the Catholic Sisters in France for their homes for war orphans."

The 9th division continued to fight their way through Europe, stopping to check empty houses for provisions. Victor found a camera in an abandoned residence.

"I kept the camera in my gas mask carrier and took pictures wherever I went. Later, we captured a Leica factory which made cameras and film. I've always kept busy and while we were waiting on the Russians at the Elbe River, one of my buddies showed me how to develop pictures."

Bored by the constant waiting, he also watched a

Czechoslovakian man work on Volkswagens. When he became aware of Victor's interest in mechanics, the man offered to be his teacher.

"He was very precise and I had to do everything right. I learned to pull the engine out in ten minutes. When I got back to the states, I repaired Volkswagon engines as a hobby.

As they moved through Europe and the war began to wind down, Victor and his comrades found themselves in two of Europe's most ferocious centers of combat, the Battle of the Bulge and the Remagen Bridge.

The Battle of the Bulge was the German army's last major offensive, designed to defeat the allied forces and drive them back across Belgium and Luxembourg. The assault on the western front began in late December of 1944 and lasted well into January. Although the Germans eventually failed, they were able to surprise two regiments of U.S. troops, who fell amidst the resulting confusion. It was the largest land battle in which the United States was involved with more than a million men participating. Both sides suffered horrendous casualties. The U.S. alone lost 19,000 men.

The Remagen Bridge was famous because of its beautiful architecture spanning the Rhine River, separating France from Germany. Built between 1916 and 1918, it served as a railway passage. The Americans' determined attempt to capture was met by the Germans' desperate and equally determined attempt to destroy it. When it was bombed by Hitler's planes and still didn't fall, he sent navy divers to blow it up.

"It was there I first saw German jets. They were moving so fast our anti-aircraft guns couldn't hit them. One of my buddies was an MP guarding the bridge and he was so scared he began to pray. He told the Lord 'If you get me through this mess, I will serve you' When he got out of the service, he became a priest and now lives in Kansas."

Ten days after it was captured by U.S. forces, the severely weakened bridge finally collapsed. Fortunately, American engineers had built a pontoon bridge to take its place.

Now referred to as the river of "flowing history," the Rhine's current was and still is very swift. When one of the 9th Division's soldiers tried to swim in it, he was almost swept under. Because Victor was a strong swimmer, he jumped in and saved him. Years later, Victor would talk with Braves pitcher Warren Spahn and learn he'd served in the war and been at the same bridge.

"Spahn was one of the best left-handed pitcher's in history and was inducted into the Cooperstown Baseball Hall of Fame," says Victor. "Most of his fans don't know his background.

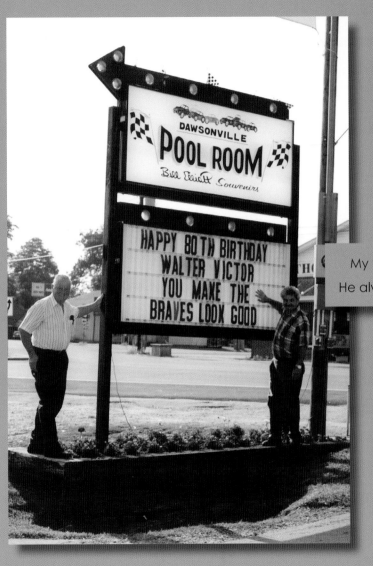

My friend Gordon Pirkle (right) owns the Dawsonville Pool Room.

He always helps me celebrate my birthday.

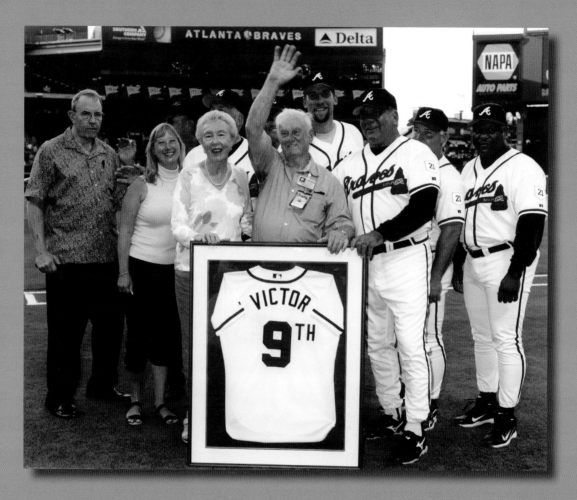

I was presented a Braves uniform bearing my WWII 9th Infantry Division number, on the night they dedicated my camera well.

When my division crossed the Remagen Bridge, we turned it over to our army's engineers and Spahn was one of them."

As terrible as it had been, the worst fighting Victor encountered left him unprepared for what the 9th Infantry Division would find when they entered one of the Nazi's infamous concentration camps. When the division moved in, conditions in the camp were beyond comprehension. Its images remain ingrained in his memory. Unable to describe the depth of the horrors he saw, he put it on film.

"Thinking about it brings tears to my eyes and I still have nightmares. There were gas ovens where bodies had been cremated and those who had lived were nearly dead. All of them were just skin and bones. Many were so emaciated and terrified they couldn't walk or speak. The Germans had killed and made slaves of the people they captured, working and starving those who survived.

"My job was to bury the remains of five thousand Jewish and Polish Holocaust victims, working with five hundred at a time. I bulldozed dirt for the burial and threw in the bodies. Our captain told me to get male civilians from a nearby town to dig the dirt to cover them. I told him they had nothing to do with it, but he said I'd been given my orders and had to follow them. My eyebrows were singed away from burning bodies and they've never grown back. I'm tough, but that experience was awful. My pictures from Dachau are the most horror-filled I've taken.

"When one of my buddies was sent home, I gave him most of my rolls of film thinking he would keep them for me. I never saw him again and am thankful I didn't give him all of them. I want people to know what happened, to never forget Dachau.

"After I left the German frontline, I headed for France. A second lieutenant tried to send me on assignment to the South Pacific, but I could take no more. I asked him, 'How many points do you have to have to go home?'"

"He said 'Seventy-five.'"

"I said, 'I have one-hundred fifty.'"

"He said 'You're going home!'"

"The war had been so bad, when I came home I just tried to forget it and put it out of my mind. I had spent five years in the army, thirty-three months of which were in combat. There were so many close calls, I'm proud I survived."

When his ship finally arrived at port, there was no one to meet him as Ruth had not been told of his return.

"I boarded a bus headed for North Carolina and got off at Chadbourn where a man offered to take me to Ruth's

parents' farm. What a surprise she had when she saw me!"

The two stayed with Ruth's parents in their newly built farmhouse until they could make their plans.

After the war, Walter Victor was awarded four Bronze Stars, one Service Star, and eight Combat Stars for his outstanding military service.

"I was told my work had been a decisive factor in warding off German attack. I don't think of myself as a hero. I just did my job."

On his way back to the states, Victor's camera had been stolen. One of the first things he did was to get a new one and take a photography workshop offered by Eastman Kodak. Filled with regret at not finishing high school, he also took and passed the GED. Remembering the offer of work, Ruth and Victor went to the Pentagon in Washington to look up the man whom Victor had helped, who had been Chief of Staff.

"I reminded him of his promise to get me a job. He told us to go home a few weeks and rest because we'd been through hell."

"After a couple of weeks, we received papers telling us we could go anywhere in the United States. Ruth picked the Atlanta area because she remembered Tara in *Gone with the Wind*.

Victor spent the next thirty-three years working as a civil service vehicle inspector at Fort Gillem Army Depot in Forest Park, Georgia, never taking a day of sick leave.

"When I told them I was retiring, they counted an extra year."

A social and outgoing person, Victor is a member of the Masons, the Elks, and the Braves 400 Club. Although it's been over fifty years, he still shares his wartime experiences.

"People may wonder why I'm still talking about what we went through, but it is as much a part of me now as it was then. I'm one of the lucky ones because I survived to tell about it. World War II is something our country must never forget and talking keeps the memories of my buddies alive.

"Although a lot of time has gone by, I still stay in touch with my wartime friends. Every year Ruth and I go to my 9th Infantry Division Reunion. In 1970, our division returned to Utah Beach. It was one of the hardest and one of the most healing things I have done. We attended our annual reunion in New York, then one hundred and sixty-eight of us left for Europe. When we flew into England, there were five buses waiting for us.

"We spent a few days in England before going by boat to France. We stopped at the places we had liberated and the people made our visit a holiday, greeting us with open arms. When we went to Utah Beach, our hearts were filled with sadness. We lost so many young men there. There is a cemetery filled with graves, but the grounds are beautiful. One of the

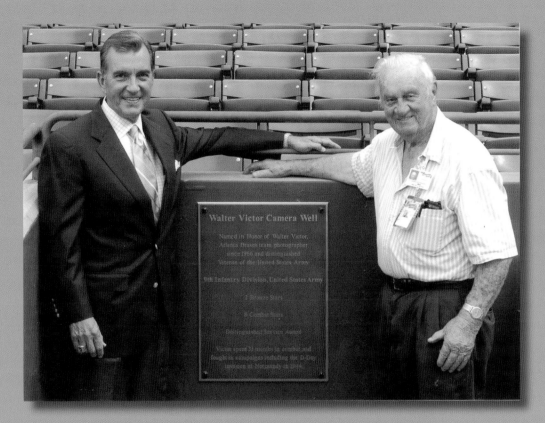

The plaque reads:

Walter Victor Camera Well

Named in Honor of Walter Victor,
Atlanta Braves team photographer
since 1956 and distinguished
Veteran of the United States Army

9th Infantry Division, United States Army

3 Bronze Stars

8 Combat Stars

Distinguished Service Award

Victor spent 31 months in combat and
fought in campaigns including the D-Day
invasion at Normandy in 1944

In 2004, the Braves claimed still another Division title, John Smoltz set a record for all-time saves, and I had the most wonderful moment of my life. In a pre-game ceremony at Turner Field, The Atlanta Braves honored me by giving me my own camera well with a plaque displaying my name.

Braves executive John Schuerholz joins me at the dedication of my camera well at Turner Field on Wednesday, May 19, 2004.

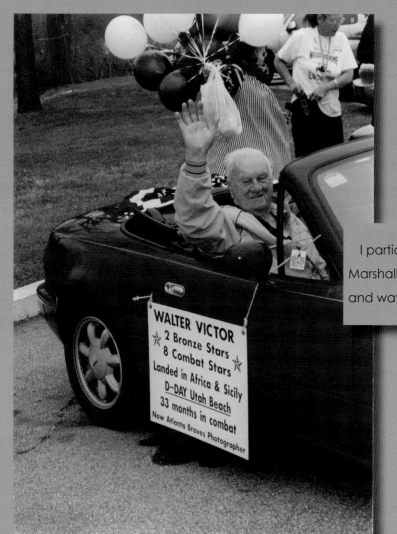

WALTER VICTOR
☆ 2 Bronze Stars
8 Combat Stars ☆
Landed in Africa & Sicily
D-DAY Utah Beach
33 months in combat
Now Atlanta Braves Photographer

I participate in many Veterans' Day Celebrations. When I was Grand Marshall of Dahlonega's Veteran's Day Parade, I rode in a red sportscar and waved to everybody.

women with us had lost her son and had his remains shipped home to North Carolina. She said if she had known how lovely the burial ground is, she would have left him right there.

"From France, we traveled to Belgium and Germany, and stopped by the Rhine. Although our tour was often painful, we shared scenic side trips and fabulous meals. We stopped at every place we heard polka music. I just wish our buddies who died could have been there with us. Our hearts alternated between feelings of happiness and camaraderie, and a sorrow-filled emptiness.

"On a humorous note, the people arranging the tour had done so at a very good price. Unfortunately, our bargain didn't last. Before it ended they gave out of money and we all had to chip in to get home. We had a good time together and took hundreds of pictures, although I'm not in them, because I was taking them."

While he was employed at Fort Gillem, Victor lived in nearby East Point where he worked part time for the West End newspaper and United Church Directories. He loved photography, especially related to sports, and moonlighted at night and on weekends.

One fall, the newspaper wanted a special picture to kick off the holiday season. Victor took one of a little girl crying while holding an ax beside her Thanksgiving turkey. The Associated Press picked it up and it was circulated all over the world.

A few years later, he shot a picture of Congressman Weltner throwing the first baseball in a little league game. When he sold it to *Life*, and an Italian magazine, called *Panorama*, his photography career was established.

"I try for the best shot, a special person or a special event. Film is cheap and if you miss a picture you can't go back. That moment is past.

"I've made tens of thousands of pictures for weddings and church directories but sports are what I love best. I've taken pictures of the Braves, Hawks, Falcons, and NASCAR. I've got shots of Michael Jordan, Deion Sanders, and Dale Earnhardt. I don't take hockey pictures because a hockey puck broke my camera the first time I went to a game. Once when I was photographing a Falcons game, running back Tony Jones sped into the sidelines and ran over me. Jones limped off the field but I got back up and started taking pictures again."

The photographs Victor took during his time in the service are a stark contrast to the pictures taken after his return. Whereas the first depict scenes of incomprehensible horror, the latter portray people at their happiest. Perhaps that is their purpose, to purge the images of war, indelibly imprinted on his mind. His photography has preserved a link to the past and it has also been a passport to more joyous times.

The Atlanta Braves have a rich and exciting history beginning with the Cincinnati 'Red Stockings,' one of our country's first professional teams. The team was formed in 1869 by Harry Wright and quickly became successful. Unfortunately, they were not financially stable and returned to amateur status after their first season.

In 1871, Wright and Boston entrepreneur Ivers Whitney Adams helped organize the Boston 'Red Stockings.' The team made baseball history by being a charter participant in the 1871 formation of the National Association of Professional Baseball Players. The 'Red Stockings' continued their participation when the Association was replaced in 1876 by the National League.

By 1883, the franchise name had been changed to the 'Beaneaters' in honor of Boston and because of the confusion caused by the American Association's Cincinnati 'Reds.'

"The name was again changed in 1907 when the Dovey Brothers purchased the franchise and called it the 'Doves.' Anxious to rid itself of the wimpy name, the team presented itself as the 'Rustlers' in 1911, a tribute to Club President William Russell.

After Russell's death in 1912, the team was nicknamed the 'Braves.' The name held for over two decades, but when the players went through a slump in the early thirties,

team officials thought a name change would help. The team greeted the 1936 season as the 'Bees,' a name chosen by fans through a poll. In 1941, the 'Braves' name returned and has been the franchise choice ever since.

By the early 1950s, the 'Braves' were experiencing dwindling support in Boston and President Lou Perini decided it was time for the franchise to move. Milwaukee, which was home of the Braves' major farm team, was hungry for professional players and welcomed the Braves with open arms. It was a marriage made in heaven.

Sadly, by the early sixties, Milwaukee's love affair with the Braves was over. The team was again in a slump and attendance was down. Players such as Hank Aaron and Warren Spahn attracted attention, but the franchise as a whole failed to draw crowds. Just as enthusiasm hit an all-time low, a sports-hungry South put forth a proposal.

Meeting in secret, Atlanta Mayor Ivan Allen Jr. and the Chicago-based LaSalle Corporation, which owned the Braves, discussed moving the team to Atlanta. After reaching an agreement, which included the building of an $18 million stadium, the Braves prepared to leave for the 1965 season. The National League granted permission but delayed the move for a year.

Like a spurned lover, Milwaukee tried to hold on, besieging the team with court proceedings. The Braves intensified the city's pain by rallying for a hopeful but inconsistent last year, bringing the season to a close in a barrage of homers. That summer, Milwaukee County and the state of Wisconsin filed lawtrust suits against the Braves and the National League, to no avail. Atlanta was home.

life with the braves/brave at heart

O n the day of any home Braves game, fans who arrive early can watch the players go into their dugout and a white haired older man walk onto the field. Walter Victor has become a stadium landmark. His shoulders drooping from the weight of his camera box, he greets the players as they arrive, comments on their good performances and wishes them well. It has become a ritual at Turner Field and some members of the team won't play until they shake his hand. In the old days, he kissed the first ball at the beginning of games, to bring good luck before it was thrown. Victor, the official Braves photographer, has been a part of the team for over forty years.

Now, a grandfather figure, he is a symbol of the warmth, strength, and endurance of the Braves family. With them through good times and bad, he has watched team members and their families, grow and develop, preserving their memories through thousands of pictures.

According to METS photographer Ray Cobb, Victor is as much of a tradition as the grass on the field. His camera has recorded a history not only of the organization but its members' lives. Since he began working for the Braves, Walter Victor has taken over 20,000 pictures. It all began in 1966.

"I was so excited when the Braves came to Atlanta," says Victor, "There were no other major league southern baseball teams at that time and Atlanta really wanted the Braves. The city built Atlanta-Fulton County Stadium especially for them.

"I went to the Braves' inaugural night and talked an usher into letting me onto the field. I didn't have any credentials, so I just showed up and kept going back. I was run off a few times, but I was persistent and when I gave the players their pictures, they loved them.

"Hank Aaron was hot back then, and with the Braves' move to Atlanta, he became even hotter. People called the stadium his launching pad, because it was right after they moved to Atlanta he broke Babe Ruth's record. He did it right in Atlanta-Fulton County stadium, in front of his fans.

"One of the members of the Braves organization I met during this time was Bill Lucas. Most people don't know it but

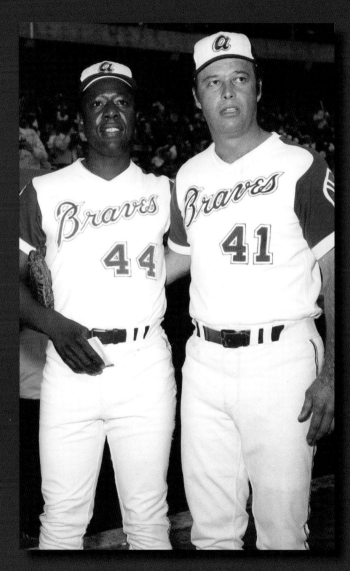

In 1966, the new Atlanta Braves rewarded stand-packed crowds with a record-setting 207 home runs, leading the league. Atlanta Stadium was nicknamed "The Launching Pad" as ball after ball soared skyward. Unfortunately, fan support and soaring balls weren't enough—the team lacked chemistry. After unrelenting criticism related to his pitching staff, manager Bobby Bragan, who had accompanied the Braves to Atlanta, was let go. In August he was replaced by first base coach Billy Hitchcock.

Fans, disappointed by the team's overall performance, focused on individual outstanding players such as Hank Aaron, Felipe Alou, Eddie Mathews, Rico Carty, and Joe Torre. Aaron, who had been a standout in Milwaukee, wowed Atlanta with forty-four homers, and led the league in RBI.

I took this rare picture of 'Homerun King' Hank Aaron and 'Captain Eddie' Mathews. As teammates they hit more homeruns combined than any other two teammates have hit while playing together—the greatest 'One-Two Power Punch' ever. Mathews played third base for the Boston, Milwaukee and Atlanta Braves, and was in three World Series. A strong team leader who helped enforce team discipline, Mathews was elected to the Baseball Hall of Fame in 1978.

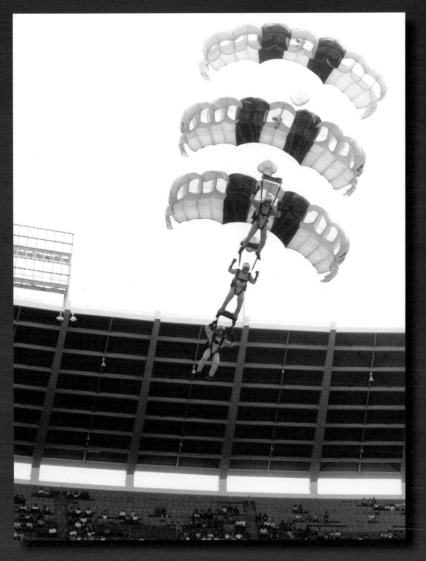

This parachute stunt was special because there were three jumpers.

Unusual events are common before Atlanta Braves games. You never know what's going to happen.

Unusual things also happen to the team. Fans were shocked at the last of the 1966 season by team anchor Eddie Mathews' trade to the Houston Astros. The sadness of his leaving was reflected in the team's dismal performance.

Before the 1967 season ended, manager Billy Hitchcock was replaced by Coach Ken Silvestri and injuries sidelined many players. It was up to individuals to thrill fans with outstanding play. Hank Aaron was a highlight, leading the league in home runs. Other good performers included new third baseman Clete Boyer, Pat Jarvis, and Phil Niekro, who led the league in ERA. His brother Joe Niekro was also a pitcher. Together, they won 539 games, the largest number in history to be won by siblings. They faced each other in July, with Phil starting for the Braves and Joe starting for the Cubs. Phil and the Atlanta Braves won, but it didn't surprise me. Niekro was phenomenal.

In 1968, former Atlanta Crackers pitcher Luman 'Lum' Harris became manager. Braves President Bill Bartholomay, keenly aware of racial pressure on Hank Aaron and inequity toward African-Americans, hired Satchel Paige as assistant trainer and coach, enabling the famous black former pitcher to acquire a National League pension. Braves pitching came together with Ron Reed, Pat Jarvis and Phil Niekro.

1969 marked the introduction of divisional plays. The addition of first baseman Orlando 'Cha Cha' Cepeda put Braves' chemistry at an all-time high. Everyone pulled together as the team led the league in fielding percentage. Phil Niekro had a fan-wowing season, paired with rookie catcher Bob Didier and when the Braves won the West Division, Atlanta went wild.

Pictured at left is Phil Niekro, one of the most beloved players in Braves franchise history. He was master of the formidable 'knuckleball,' which struck fear into the hearts of batters. Beginning with the Milwaukee Braves in 1964, he came with the Braves to Atlanta, playing with the team through 1983 and also in 1987.

The early seventies started with illness, injuries, and pitching problems. In 1972, opening day was delayed by a strike and that set the tone for the season. Luman Harris was blamed for the team's poor showing and was replaced by Eddie Mathews. The bright spot was the Braves' formidable offense and the building suspense of Hank Aaron's chase for Babe Ruth's record.

Darrell 'Howdy Doody' Evans, Hank Aaron, and David Johnson are shown here together in 1973. Rarely does a team have three hitters knocking out forty or more homers in one year. Evans hit forty-one, Aaron hit forty, and Johnson hit forty-three.

Darrell Evans was the first baseball player to hit forty homeruns in both the American and National leagues. With the Braves 1969-1976, Evans was traded to the San Francisco Giants, returning as a free agent for the 1989 season.

David Johnson came to the Braves from the Baltimore Orioles. He played with Atlanta 1973-1975.

Aaron was a consistently powerful hitter known for his running speed. He'd been a teenage football star, unable to play baseball for his high school because they didn't have a team. Nicknamed "Bad Henry," "Hammering Hank," and "The Hammer," Aaron had a unique wrist action in his batting style and was also famous as an outfielder. He was elected to the Baseball Hall of Fame in 1982.

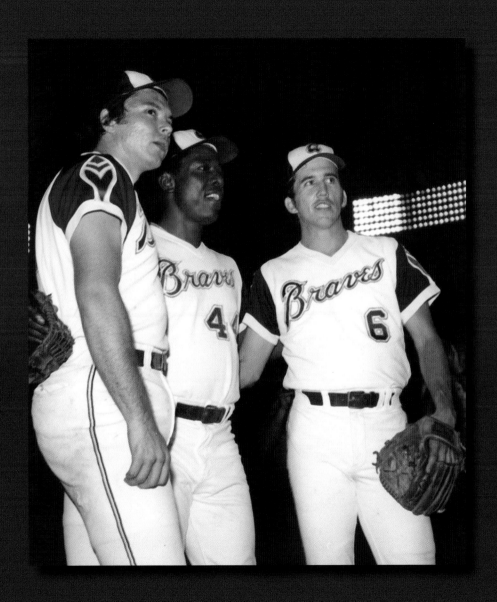

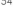

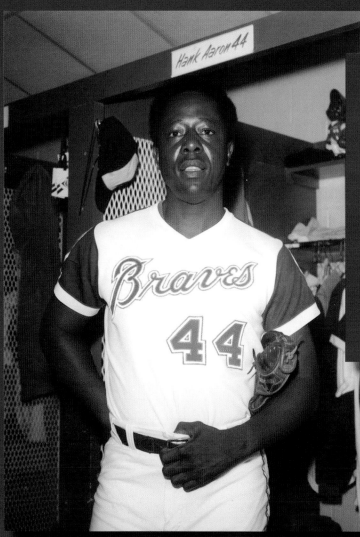

Wow! What an opportunity for me! I took this shot on April 8, 1974, a date that is burned forever in major league history. All-time home-run king Hank Aaron stands in front of his locker after hitting run # 715, breaking Babe Ruth's record.

1974 was a year of joy and turmoil for all of us. The season opened with everyone waiting for Aaron to break Babe Ruth's record and hoping it would happen at home. Aaron hit his 714th home run at Cincinnati on April 4th, the League's opening day. Four days later, he treated Atlanta to his record-breaking 715th. The achievement brought joy and relief to the 'Homerun King' who had been subjected to media pressure and death threats.

Lucas was one of the first blacks to be hired in an executive position in the National League. The Atlanta Braves have made a big impact on major league and African-American history. They had Hank Aaron hitting the most home runs ever hit in baseball, and put Bill Lucas in the Braves' front office.

"Lucas was a former player in the Braves' farm system and began his Atlanta baseball career in 1965, working in public relations for the Atlanta Crackers. The Crackers were formed in 1901 and played until 1965. They were one of the most entertaining and powerful minor league clubs in the nation and always had impressive players. They showed off the talent of young athletes at the same time they welcomed former major leaguers.

"When the Braves came to town, Lucas's professionalism and experience were recognized and he was hired as part of the Milwaukee-Atlanta transition team. A short time later, he became the Braves' farm director. When people ask me how the Braves get so many good players coming up from the farm teams, I tell them it's because of Lucas. He transferred his experience into setting up the Braves' minor league system still in place today.

"What was important to me was he also worked as the team's Director of Personnel. Lucas saw me on the field at every game. When I retired from Fort Gillem, he asked if I wanted to be the Braves' official photographer. He chose me over all of the other applicants and I've been with the team ever since. Lucas saw my persistence, which has always made the difference in my life."

Whether it was getting weapons to the troops in World War II, winning Ruth Martin's heart, or, becoming the Braves' photographer, when Victor sets a goal he never gives up. That may be why he and the team fit together so well. The Atlanta Braves are also known for their determination.

"The players and I have been through a lot together," says Victor. "It's hard to see them losing and I love to see them win. Fortunately, they win a lot. My most enjoyable moment was in 1995, when the Braves won the World Series. My happiest photographs are from that game."

Victor's camera bears witness to history, sometimes happy, sometimes sad, and sometimes bizarre.

"In 1976 media magnate Ted Turner bought the Braves. Fans had a fit because he was a 'hands-on' type of owner, but didn't know anything about baseball. The Braves assigned Rick Camp, who was one of their minor league players, to

Hank Aaron celebrates his record-setting 715th home run at an Atlanta press conference after the game. His smile says it all.

The 1974 season was marked by an offensive slide but pitching improved. Buzz Capra added bullpen chemistry while Niekro provided stability. Eddie Mathews was fired as manager and replaced by Clyde King, but King's reign was short-lived. He was replaced by Connie Ryan the following year. In 1975, we still couldn't get it together. The team was mediocre and without the drama of Aaron's hitting, attendance plunged.

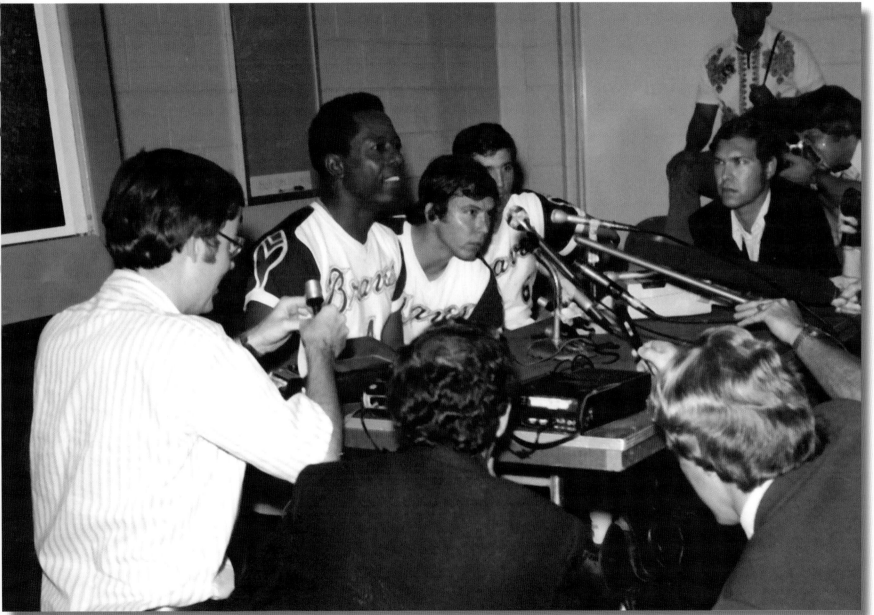

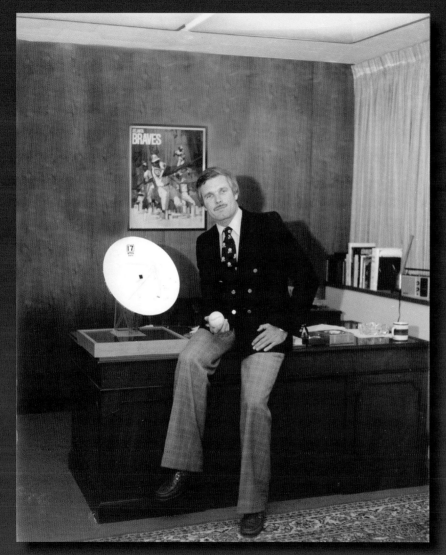

In 1976, TV Channel 17 owner Ted Turner bought the Atlanta Braves for $10 million. The team changed owners and the stadium changed names, becoming Atlanta-Fulton County Stadium. The team also had Dave Bristol as its new manager.

When Turner took over the Braves, the team was lackluster and attendance had dwindled. Turner, who had no baseball experience, was assigned rookie pitcher Rick Camp to teach him the ropes. Determined to turn the team around and increase its number of fans, Turner upset baseball's officials with his crowd-pleasing antics and stunts.

Turner was accused of being an attention-grabber, meddler and showoff, but his enthusiasm was contagious. He surprised everyone by becoming one of the biggest contributors to the Braves' success. Known for his deep pockets, he put the team in trading frenzy and offered multi-million dollar contracts to veteran free agents. The result had a huge impact on baseball's salary scale, and a whopping impact on Atlanta.

Ted Turner and His son, Bo, meet the San Diego Chicken. Turner promoted the personalities of his players like authors promote characters in a book. He turned out to be the biggest storybook hero, constantly overcoming conflicts with baseball authorities. During one of his creative moments, and there were many, he decided to put player nicknames on the back of team jerseys. To advertise his cable network, he had 'Channel' put above pitcher Andy Messersmith's uniform number 17. Baseball authorities immediately put a stop to Turner's shenanigans and ordered all nicknames removed.

Ted Turner was a hands-on type of guy and always meant what he said. He told his son Bo to get a haircut and when Bo didn't do it, Turner sat him down and cut it.

In 1977, Turner was frustrated with the Braves' performance and decided to see what was going on for himself. In May, he sent Dave Bristol out of town, put on a uniform, and took over Braves' management. Horrified National League officials quickly ordered him out. As the seasoned worsened, Turner was suspended for tampering and Bristol was fired.

teach him the game. Turner was a fast learner and, in 1977, tried to manage the team. He had his fingers in everything, even my pictures.

"I used to take lots of shots of my subjects but Turner suggested I take just one. Since he was my boss, I tried that, and he was right. Of course he didn't know he'd be the subject of so many of them.

"When I aim my camera, I always look for a good background, get the men to take their hands out of their pockets and the women to straighten their hair. The hardest thing is when I get set and somebody else shoots before I do. That can mess you up. I have digital cameras now but I don't like them. I'm too old to learn new things and my best pictures are all from the old ones."

"Photography is fun, but the best thing about it is the people. You never know who you'll meet or what to expect. I've shot Deion Sanders and Michael Jordan, O.J. Simpson's last run, Hank Aaron after his record-breaking homer, and, sadly, Dale Earnhardt's last ride around Atlanta Motor Speedway.

"Every time I go to a game, there's something different to do. I've met Dale Murphy, Phil Niekro, Mickey Mantle, Joe Dimaggio, and Whitey Ford, but the players aren't just celebrities, they're men. They're human beings. They put their pants on everyday like I do and they always take time for kids. If I ask them to take a picture with one of the Make-a-Wish-Foundation children, they stop what they're doing and come right over. Most of them have hearts of gold."

Because of his outstanding photography Victor has been honored with the Braves 400 Club Ivan Allen, Jr. "Mr. Baseball" Award and currently has twelve pictures in the Baseball Hall of Fame in Cooperstown, New York.

"My favorite is The Fire. I took that picture in July of 1993. The time was important because the Braves had been going through a slump and just acquired Fred McGriff. The media said the Braves needed a spark and hoped he would ignite the team. The night McGriff made his debut, the press box caught fire. I was taking a picture of Mark Lemke and Jeff Blauser when, all of a sudden, it exploded in a raging inferno. They were best buddies and just standing there proud as could be, like two mischievous schoolboys who started it. That was what I call being at the right place at the right time. Poor Fred McGriff; He had nothing to do with it, but he never lived it down."

Ruth and Walter Victor now live outside of Atlanta in Dawsonville, a region which has moonshining roots, and is the home of NASCAR Champion Bill Elliott. The

Dale Murphy is one of the most famous of the Braves' former players and one of the best performers in the team's history.

A spiritual person, "Murph" had a heart of gold, always taking time for fans, and setting an example for all of us. He was a first round Braves draft pick in 1974 and came up through Bill Lucas's minor league system as a catcher. After his 1976 major league debut, he became known for his speed as an outfielder and outstanding hitting. New manager Bobby Cox put him in the starting lineup in 1978 and over the next three seasons he hit 77 home runs. He was a two-time choice as the League's Most Valuable Player and earned five Gold Glove Awards for his fielding excellence.

Murphy played for the Braves 1976-1990.

61

Throughout the seventies and eighties, Ted Turner's antics continued, and the more he entertained, the more he was loved by fans.

Turner made a bet with relief pitcher Frank 'Tug' 'You Gotta Believe' McGraw that he could push a baseball from Atlanta-Fulton County Stadium's first base to home plate with his nose before McGraw could push one with his nose from third base to home plate. Turner was always putting his money where his mouth was. This time he offered his proboscis and he was victorious.

When Ted Turner won the ball pushing contest against McGraw, he sported a bloody nose to prove it. He was called 'Captain Outrageous,' but I call him 'Captain Courageous.' Turner gained national admiration and later became *Time* Magazine's 1992 Man of the Year.

64

Pitcher Steve 'Bedrock' Bedrosian is shown with Kent Mercker. Ted Turner recognized baseball as a character-driven sport and Bedrosian was quite a character. He was drafted by the Atlanta Braves in 1978, helped them win a division title in 1982, and was named National League Rookie Pitcher of the Year by *The Sporting News*.

He was traded to the Philadelphia Phillies in 1985 where he received the National League's Cy Young Award in 1987. From the Phillies, he went to the San Francisco Giants and Minnesota Twins. Bedrosian went into semi-retirement with an injured hand before returning to the Braves in 1992. He now lives in Coweta County near Atlanta where he serves on the school board.

Victor doorbell plays "Take Me Out to the Ballgame" and their house is decorated with baseball pictures and memorabilia. Their front porch faces their dock on Rainbow Lake, a twenty-six acre body of water well stocked with fish.

"I put a thousand catfish in it and have a lot of bass, bream, and perch. Two automatic fish feeders feed them twice a day and they are so big, it's hard to take the hook out when I catch them. I've caught a 1-1/2 lb. bream, 8-1/2 lb. bass, and a 16 lb. catfish, but, my best catch has been Ruth. We've been married for sixty-three years. She's been a good wife and I wouldn't trade her. She looks so good, my buddies still whistle. We have four children, Tony Van, Johnny, Tommy, and Ann Margaret, and I love them all.

"My health is still good because I never drank or smoked and I take care of my body. I have a treadmill and, instead of riding, I like to walk. If I played for the Braves, I'd want to be in the outfield to get lots of exercise. I hope to be here a long time but since I know the end will come sometime, I've donated my body to Emory University Hospital for research. Some people may think I'm old, but I feel young. I drive my truck to the MARTA station and take the rail and then the bus to every Braves game at Turner Field.

"Ruth and I have been fortunate," says Victor, "and we have good friends. We enjoy good friends, good food, and good dancing. Once, Phil Niekro brought a Polish band to a game. I got their telephone number and had the band out to our lake on my eightieth birthday. It was a sight to see. Forty people were outside dancing the polka. A peacock attended the party. He must have thought he'd been invited because he lived on the lake. He became so excited he entertained the crowd, strutting his feathers while on top of our roof.

"When we celebrated our fiftieth anniversary, we rented a hall downstairs in a Catholic church and had the Polish band again. I danced so much my clothes became soaking wet. I don't know what we'll do for our seventy-fifth, but we'll come up with something.

"I'm so lucky. I have a whole stadium full of friends and everybody knows me by name. When I give people their pictures, it makes them happy and that's what I live for. In looking back I've had a good life. It's been hectic, but I'm still in one piece and it's been interesting hasn't it? I love taking pictures and I love the Braves.

"I hope this book makes you happy and you enjoy it. I think we have a good book, don't you?"

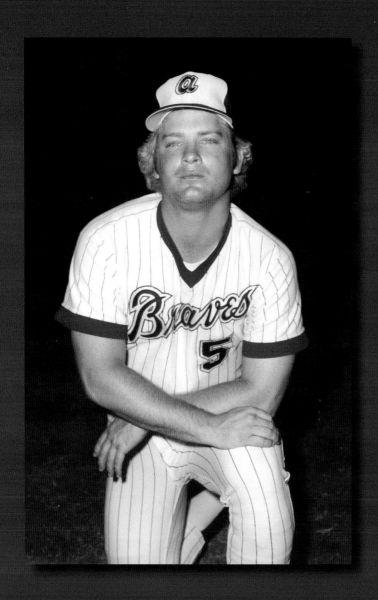

The late seventies and early eighties were highlighted by great players such as Phil Niekro, Dale Murphy, Gene Garber, and Bob Horner.

Bob 'Mr. Ho Mah' Horner was the Braves number one draft-pick in 1978. Horner played both first and third base and was an excellent hitter. He was playing for Arizona State when the season began and went straight to the majors where he hit a homer in his first game. He became 'College Player of the Year' and 'National League Rookie of the Year' in the same season. In 1979 he became the highest paid player in franchise history.

Often at the center of controversy, Horner was with the Braves from 1978-1986. He left to play in Japan at the height of his career, returning later to play for St. Louis. He made an attempt to play for Baltimore in 1989 but had to retire due to an old shoulder injury.

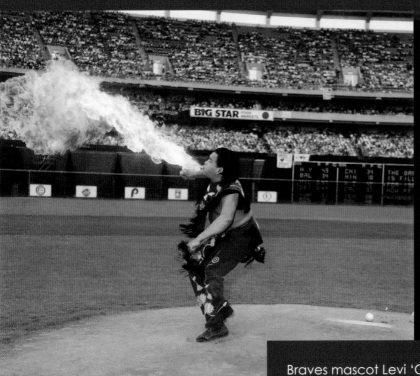

Braves mascot Levi 'Chief Noc-a-Homa' Walker was one of the best-known of all Braves employees. He worked for the Club for seventeen years, starting every game with a war dance on the pitcher's mound before running to his tepee in the left-field stands. I took this shot of him, demonstrating his fire-breathing trick. Every game he attended was punctuated by war cries. His last performance was in 1986 and we were all disappointed to lose him.

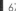

During the eighties, the Braves were known as 'America's Team.'

1981 was a tumultuous year with players on strike, Turner hiring free agents, and manager Bobby Cox fired. The popular Cox, who was replaced by Joe Torre, soon had a job in Toronto.

In 1982, the Braves set a Major League record by winning their first thirteen games, then roller-coastered into the playoffs. Niekro was disabled part of the time, and pitching was inconsistent, but Chris Chambliss, Gene Garber, Steve Bedrosian, Dale Murphy, Glenn Hubbard, Bob Horner, and Brett Butler helped lead the team to the West Division title. Murphy was named the National League MVP and won the Gold Glove Award. Attendance was up and excitement was growing.

On a comical note, Pitcher Pascual Perez was called up from the minor leagues to begin a home game against Montreal. Just having received his driver's license, he attempted to drive to the field by himself. After circling I-285 two or three times, he finally made it, but the game had already started. From thence he was known by many as '285' Perez. The incident incited a storm of publicity.

Brett Butler, shown at right, played for the Braves 1981-1983. A great center fielder with fantastic speed, Butler was a hit with the team and the fans, but would soon be traded to the Indians.

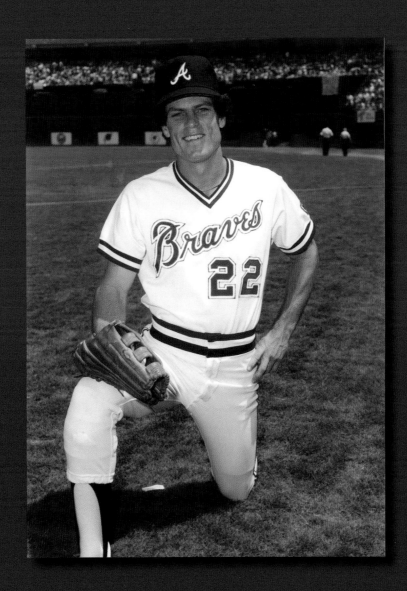

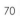

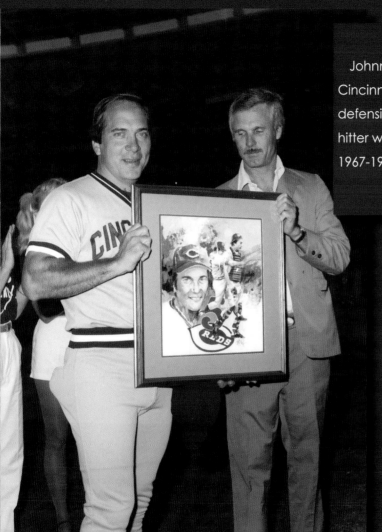

Johnny Bench, shown here with Ted Turner, was a catcher for Cincinnati's 'Big Red Machine' and is considered one of the greatest defensive catchers of all time. An all-around outstanding athlete and hitter who could play almost any position, Bench played for the Reds 1967-1983, and was chosen repeatedly for the National League AllStars.

In 1983, attendance was climbing but it was a bad year for Bob Horner, who broke his wrist sliding, and for Phil Niekro, who was released. Niekro's release angered and upset the fans; he had been their hope and their hero through many seasons.

Niekro had signed with the Milwaukee Braves in 1958 and came with them to Atlanta, where he remained until 1983. In 1984 he went to the New York Yankees, and in 1986 to the Cleveland Indians. He played for the Toronto Blue Jays before returning to the Braves in 1987.

Phil Niekro throws out the first ball at Atlanta-Fulton County Stadium during one of his special return visits. Atlantans will always love 'Knucksie.' In 1997, Niekro was inducted into the Baseball Hall of Fame in Cooperstown, New York.

It all started when Braves pitcher Pascual Perez hit Padres' batter Alan Wiggins in the back with the first pitch of the game. The Padres' pitchers retaliated by throwing at Perez each time he came to the plate. There were two brawls, with nineteen ejections, before it was over. The players became so upset, both dugouts emptied and fans got involved.

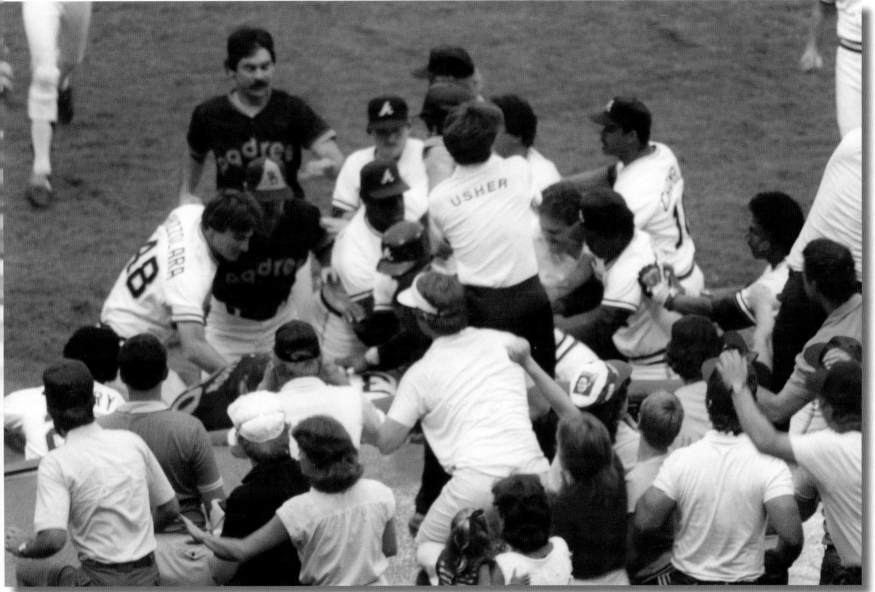

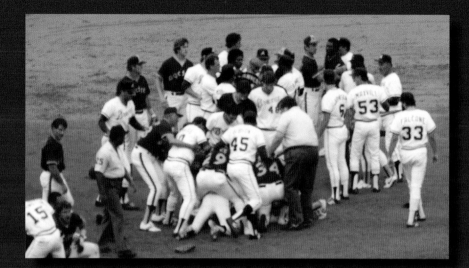

In 1984, an air of gloom fell over the stadium. Phil Niekro was gone and pitching was down. He won sixteen games for the New York Yankees, proving he wasn't too old, while his vacancy on the Braves seemed like an empty hole.

The season started off slow, then sped through a nine game winning streak before going on a downhill slide. Pascual Perez and Rick Mahler pitched well but Bob Horner broke his wrist again and Len Barker had elbow problems. The bullpen couldn't get it together, nor could the team as a whole. The year was one of instability and frustration. Before the year ended, Joe Torre was fired.

As if the trouble within the team wasn't enough, a disagreement with the San Diego Padres got out of hand. On August 12, 1984, one of the worst fights in baseball history broke out, recorded here for all time by the camera.

Braves pitcher Gene Garber got into the fight and the fans went crazy. Garber came to Atlanta in 1978 and stayed until he was traded to the Kansas City Royals in '87. Wow! That guy was a saver.

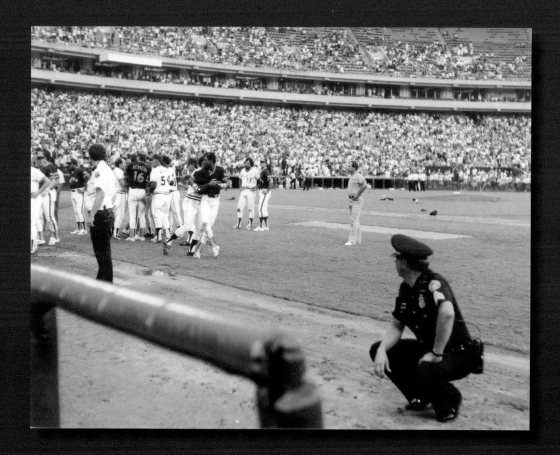

A policeman looks on during the Braves VS Padres fight. There wasn't much he could do. If he'd gotten involved, we'd have had a bigger mess. Joe Torre and five of his players received a three day suspension and Padres Manager Dick Williams was given a ten day suspension and $10,000 fine.

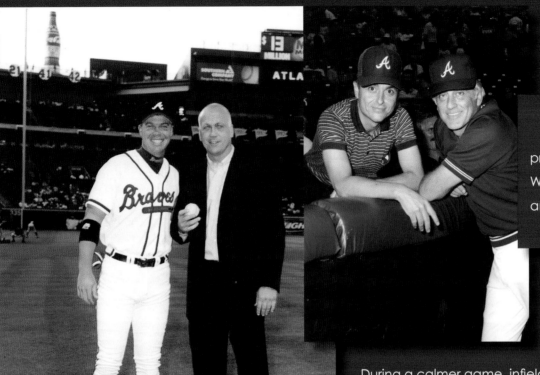

Phil Niekro, shown here with professional bass fisherman Orlando Wilson, remains one of the most popular and respected Braves.

During a calmer game, infielder Chipper Jones is shown on field with former Baltimore Orioles shortstop Cal Ripkin. Described as a blue-collar warrior because he took his work so seriously, Ripkin played for the Orioles from 1981-2001. He broke Lou Gehrig's record for most consecutive games played and is considered one of the best short stops who ever played the game.

1985 started out a terrible year. Braves manager Joe Torre was replaced by Eddie Haas, who was fired before the season ended and temporarily replaced by Coach Bobby Wine. Rafael Ramirez and Glenn Hubbard played well but Bob Horner and Dale Murphy were the only serious offense.

October is a month for strange happenings and in '85 it proved no exception. Former Pittsburgh manager Chuck Tanner was hired to be the Atlanta Braves' fourteenth manager and, like a ghost from the past, Bobby Cox came back as general manager.

In 1986, the team fared no better. Both pitching and offense were poor. During the 1987 season, Rick Mahler raised fans' expectations with an opening day shutout, but hopes were soon dashed. A highlight was Phil Niekro's brief return to start the last home game, in honor of his lasting impact.

Phil Niekro is shown with his statue, a tribute to his outstanding performance. Niekro was one of the longest lasting pitchers in major league history, pitching his last game at age forty-eight.

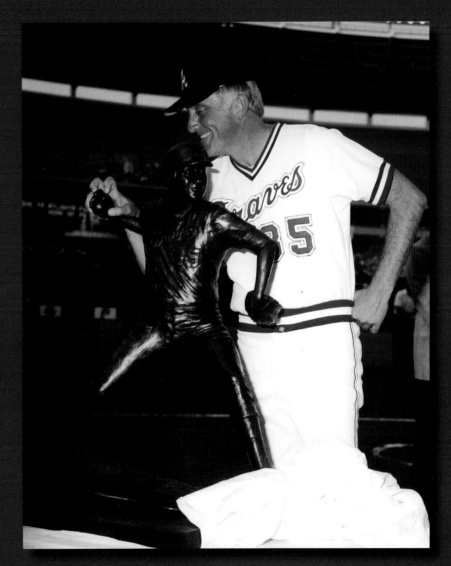

In 1990, the Braves sent shock waves throughout baseball when they traded Dale Murphy. The year saw sporadic successes punctuated by disappointment as the team tantalized fans with unfulfilled promises. Russ Nixon was fired and Bobby Cox returned to his position as manager. Although Turner did everything he could money-wise to bail them out, the Braves had one of the worst years in baseball. Individual players who excelled included David Justice, who moved into Murphy's position in the outfield.

Above, Dale Murphy receives an award from Braves executives. From left to right are Stan Kastin, John Schuerholz, Bill Bartholomay, and Dale Murphy.

Mark Wohlers accepts an award for Greenville Player of the Year from Braves executive John Schuerholz. Drafted by the Braves in 1988,he was traded to the Cincinnati Reds in 1999, and from there he went to the Yankees, then the Cleveland Indians.

3

GREG
OLSON
TOM
GLAVINE

1990 saw a revitalized Ron Gant and one of the bright lights of the year was catcher Greg Olson. Olson, who was pulled from the minors, moved to AllStar status within months. Another promising young player, Steve Avery, made his major league debut that year. Both played with their hearts. If a player has 'heart,' he's hard to beat.

This photo is of pitcher Tom Glavine and catcher Greg Olson. Olson's stay with the Braves was short-lived. He was released after the 1993 season.

Former Vice President Al Gore throws the first ball in a game at Atlanta-Fulton County Stadium.

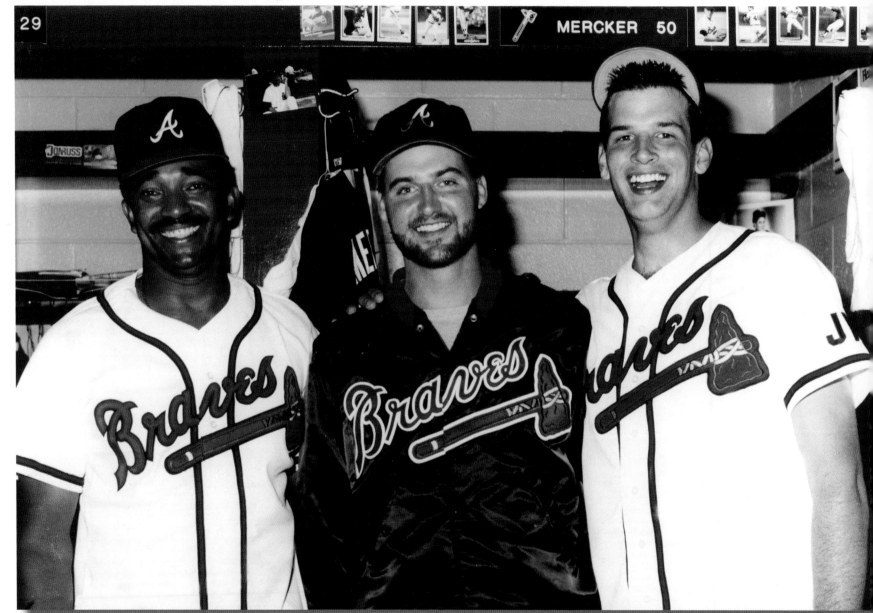

Despite 1990's dismal performance, seeds were sown that would soon propel the Braves forward. First, Pitching Coach Leo Mazzone began working with Tom Glavine, John Smoltz and Steve Avery. Second, Braves fans prayed for a savior, and John Schuerholz answered, accepting the position as Braves General Manager.

From then on, years would be broken into two eras, 'Before Schuerholz' and 'After Schuerholz.' Three years had passed in desolation, but, that was 'Before Schuerholz.' When the 1991 season began, he had signed a host of new players, including Deion Sanders, Sid Bream, and Terry Pendleton. The year marked a new beginning as the team gradually, then like a zooming comet, would rise from the dead.

In 1991, the Braves started at the bottom of the League. Fans and rivals considered them a joke and expected another woeful year. At first, the season dragged, then, by May picked up speed, only to be beset by injuries. When Sid Bream and David Justice were sidelined, gloom, again, spread through the stadium. Lonnie Smith, and newcomers Brian Hunter and Keith Mitchell, were called on to take up the slack.

When the new players were added, it took time for the mixture to gel, then, suddenly the Braves exploded, beginning a move toward first place. In August, when pitcher Juan Berenguer became disabled, emotionally-wrenched fans feared the worst. Schuerholz quickly signed Alejandro Pena from the Mets as replacement and the Braves pushed onward.

The picture at left is in the Baseball Hall of Fame. Pitchers Alejandro Pena, Kent Mercker, and Mark Wohlers pitched a no-hitter against San Diego on September 11, 1991. Mercker pitched the first six innings; Wohlers, the seventh and eighth; and Pena closed out the ninth. It was the first multi-pitcher no-hitter in National League history. The game ended 1-0, with the winning home run by Terry Pendleton.

The year 1991 was one of the most thrilling seasons in baseball history and saw the Braves come from 'worst' to 'first,' thanks in large part to John Schuerholz (above, with Stan Kastin), the general manager who promised to make radical changes. The Braves won the National League Pennant and faced the Minnesota Twins in the World Series. In the end, the Braves lost, but it was a splendid series, and Baseball America named the Braves the Organization of the Year.

Catcher Greg Olson poses with "Braves Best Fan," Pearl Sandow.

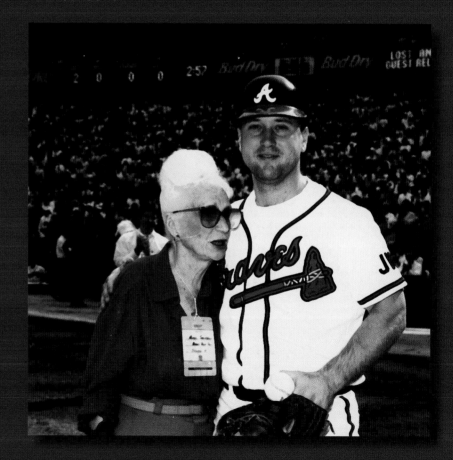

The fans broke into a frenzy of 'chanting' and 'chopping' as the Braves went on to a knock-down drag-out duel with the Dodgers. Unable to tear themselves away from the drama, those who weren't in the stadium were glued to TV and radio. When the Braves won the National League Pennant, their excitement was uncontainable and when they faced the Minnesota Twins in the World Series, it was another Civil War. Both teams had played so well, many felt the Championship should be split.

Bobby Cox, shown here peeking out of the dugout, was named 'Manager of the Year.'

85

Jeff Francoeur, right fielder for the Atlanta Braves.

Ryan Langerhans, left fielder for the Atlanta Braves.

The Braves organization is community-oriented and the players put a lot of effort into charity projects. Terry Pendleton receives an award for his effort against hunger. Pendleton was drafted in 1982 by the St. Louis Cardinals, and signed with the Braves as a free agent. In 1991, he was named NL MVP.

In 1995, Pendleton signed with the Marlins and was traded back to the Braves the next year. He signed with the Cinicinnati Reds in 1997 and the Kansas City Royals in 1998. He is now back with the Braves as hitting coach.

Pitcher Steve Avery was named Most Valuable Player of the 1991 National League Championship Series. Along with Warren Spahn and Tom Glavine, he was one of the best left-handers in Braves history. He played from 1990 through 1996 when he was granted free agency, then was with the Boston Red Sox and Cincinnati Reds before returning to the Braves in 2000. In 2003, he signed with the Detroit Tigers.

Can you believe it? In this photo, Deion Sanders proudly displays a baseball award. Deion played for both the Falcons and the Braves in the same season. He was drafted by the Yankees to play baseball in the minor leagues while playing college football and was with the Braves from 1991-1994. He also played for the Cincinnati Reds and San Francisco Giants.

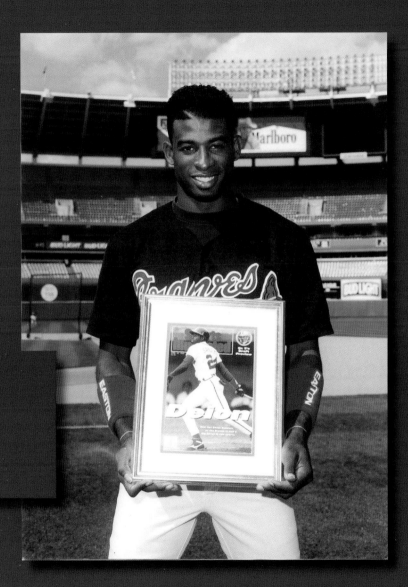

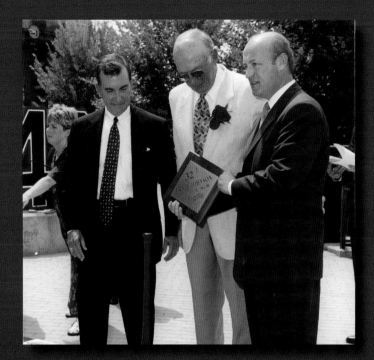

Former pitcher and announcer Ernie Johnson receives an award from Braves executives John Schuerholz (left) and Stan Kastin (right). He pitched for both the Boston and Milwaukee Braves, returned to the Milwaukee front office after retirement, and accompanied the team to Atlanta as an announcer.

Mark Wohlers is interviewed by the media in the locker room. He was a fireball who made the diamond smoke, throwing 100 mph fastballs. Wohlers was one of the best closers in the National League. He was drafted in 1988 and stayed with the Braves until 1999.

The year 1992 brought another exciting season. The Braves won a back-to-back pennant and played in the first international World Series. Tom Glavine, Deion Sanders, John Smoltz, and Terry Pendleton were among the standouts.

Braves first baseman Sid Bream (with the crutch) celebrates a win with Deion Sanders and other Braves players. Bream, who was born in Pennsylvania, came to the Braves in 1990 as a free agent. He was most famous for his extraordinary and safe slide to the plate during game seven of the Braves' NLCS series against Pittsburgh. He played for Atlanta until 1994 when he signed with the Houston Astros.

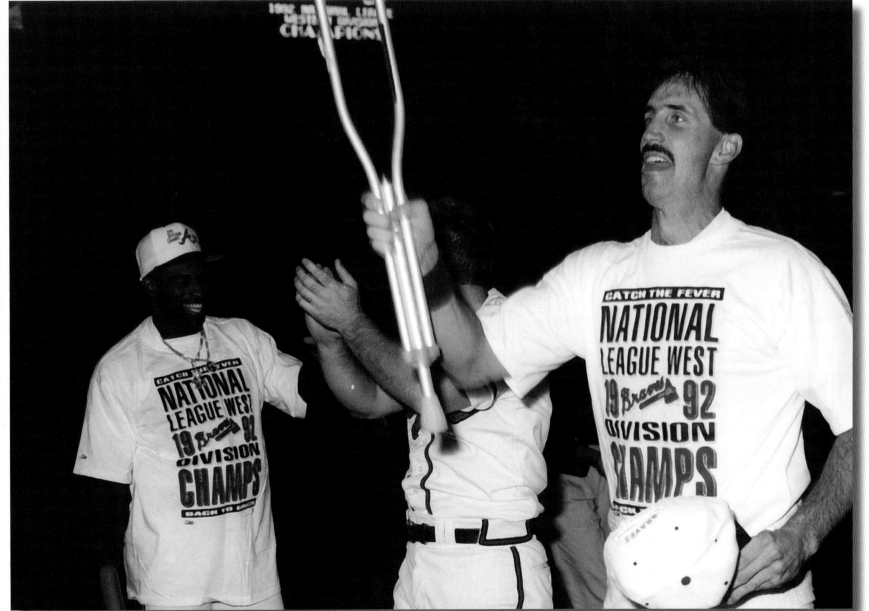

Lonnie 'Skates' Smith played for the Braves from 1988-1992 as an outfielder. This picture of Smith was taken when the Braves played against the Bluejays during the 1992 World Series in Toronto, Canada. The stadium was extremely noisy, then, when Smith made a grand slam home-run, there was dead silence. Although the Bluejays prevailed, it was another fabulous season for the Braves, who again, overcame injuries in their star-struck quest for the Chanpionship.

The great Braves pitcher Tom Glavine is ready to throw the ball. An excellent hockey player, Glavin was offered a choice between the Los Angeles Kings or the Braves; he chose the Braves. Glavine is an outstanding pitcher, fielder, and hitter and has a fierce determination to win.

Former Braves second baseman, Marcus Giles, signed with the San Diego Padres in December 2006.

Pete Orr made his Major League debut for the Braves in 2005, and is a valuable utility player, playing second base, third base, and various outfield positions.

The ceremonial first pitch in the fourth (and final) game of the 1999 World Series was thrown by retired Yankee pitcher Whitey Ford to retired Yankee catcher, Yogi Berra. The Yankees swept the Braves to win the series.

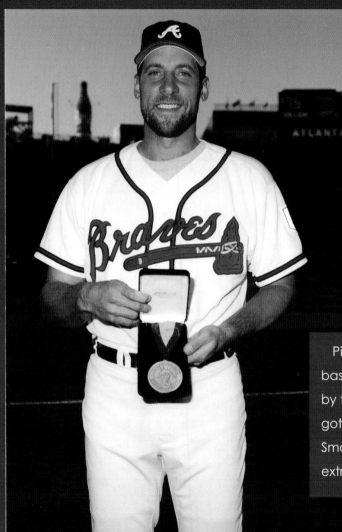

In 1993, the Braves added the magic of Greg Maddux to their pitching arsenal. Fans, prepared for another thrilling year, were not disappointed. The team became the first to win NL West for three straight years and led the league in wins, homers, ERA, and had soaring attendance. Maddux, Glavine, Smoltz, and Avery became known as the 'Fabulous Four.'

Pitcher John Smoltz receives one of many of his awards for outstanding baseball performance. The Michigan-born Smoltz was drafted in 1985 by the Detroit Tigers. He was traded to the Braves in 1987 and we really got a good one! The Braves' Tom Glavine, Greg Maddux, and John Smoltz pitching trio of the early nineties is considered one of the most extraordinary pitching powerhouses in baseball history.

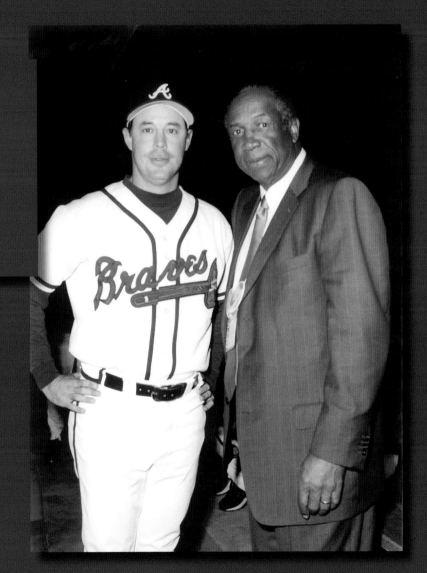

Frank Robinson is shown with Braves pitcher Greg Maddux. Now managing the Washington Nationals (formerly the Montreal Expos), Robinson was one heck of a baseball player and Maddux is too. A powerful swinger, Robinson was inducted into the Hall of Fame in 1982. He was winner of the triple-crown, the MVP in the American and National Leagues, and was the first African American to manage a baseball team. He played for the Cincinnati Reds, the Baltimore Orioles, the Los Angeles Dodgers, the California Angels, and the Cleveland Indians. He also managed the Cleveland Indians, San Francisco Giants, Baltimore Orioles, and Montreal Expos. Robinson was 1989 American League Manager of the Year.

Maddux was a dominant pitcher and was the first to be given the Cy Young Award more than two consecutive years. He is known for his consistent control of the ball and is also a strong fielder and hitter.
You couldn't meet a nicer guy.

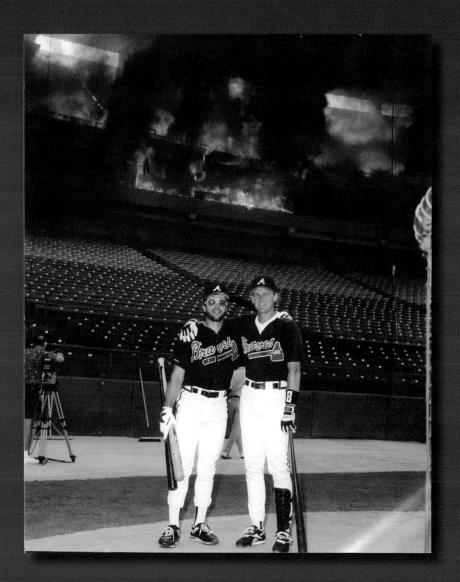

Mark Lemke and Jeff Blauser seem oblivious to the fire in Atlanta-Fulton County Stadium's press box. The flames burst out just as my camera clicked. This picture taken July 20, 1993, is in the Baseball Hall of Fame in Cooperstown.

Blauser was first drafted by the St. Louis Cardinals in 1984, but he would not sign, and the Braves got him. He went to the Chicago Cubs in 1997.

There's some humor here: a man with a tiny fire extinguisher heads for the blazing press box, apparently thinking he can put out the fire. In midsummer 1993, sportscasters said the Braves were in a slump and needed a spark. They hoped trading for Fred McGriff would provide it, but the roaring fire during his first game in Atlanta was more than they expected.

When we got first baseman Fred McGriff, he was one of the top hitters in the National League. He was drafted out of high school by the New York Yankees and traded to the Toronto Bluejays and then to the Padres. In 1993, he was traded to the Braves where he helped the team to four League Championships and two World Series. He was awarded MVP for his performance in the 1994 AllStar game. At the end of 1997, he was acquired by the Tampa Bay Devil Rays. He went from the Devil Rays to the Chicago Cubs and on to the Los Angeles Dodgers before returning to the Devil Rays.

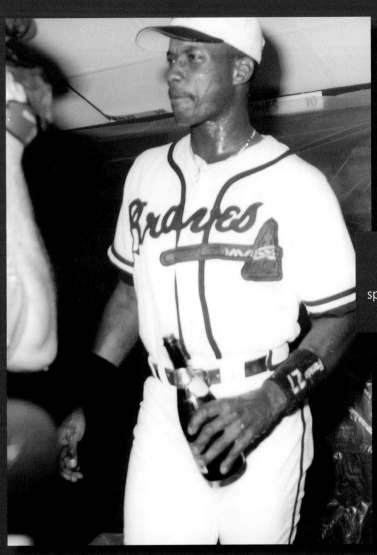

After the stadium fire, Fred McGriff was always thought of as the spark that set the Braves on fire.

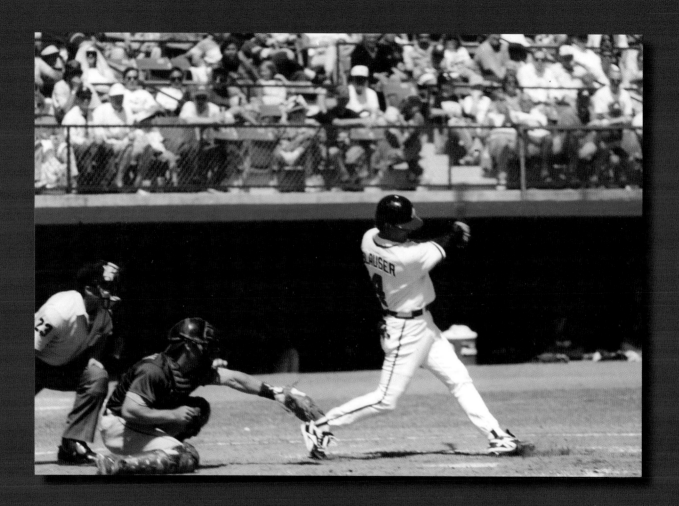

Jeff Blauser was a big morale booster. He was always up to something and kept the team on its toes.

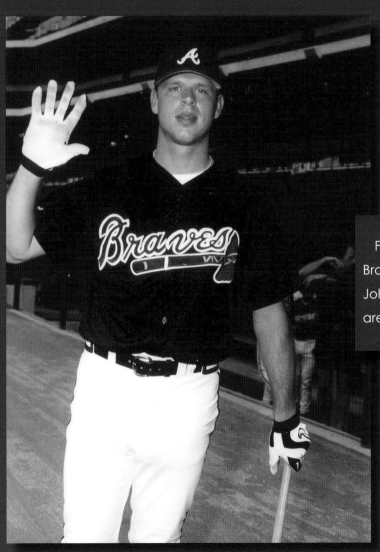

Former Braves player Kevin Millwood was drafted by the Atlanta Braves in 1993 and traded to the Philadelphia Phillies in 2002 for Johnny Estrada. He now plays for the Cleveland Indians. The players are part of our family. I always hate to see them leave.

1994 began with the team in the National League East and the Braves led the League in homers for the third consecutive season. Maddux became the first player in Major League history to win three consecutive Cy Young awards and Bobby Cox won his 1000th game. The Braves were second in the National League when all dreams were dashed by the August baseball strike. For the first time since the early 1900s, the playoffs and World Series were cancelled.

Braves relief pitcher Kent Mercker is standing in front of his locker in Atlanta, shortly after he created a sensation by pitching a no hitter against the Dodgers in Los Angeles. The Braves won the game 5-0. This picture is also in the Hall of Fame. Mercker was drafted by the Braves in 1986 and was with them until the end of 1995 when he was traded to the Baltimore Orioles.

In '94, infielder Chipper Jones had been targeted to replace Ron Gant, who was injured in a motorcycle accident, but Jones became injured during spring training. He has spent the rest of his playing career making up for it.

Chipper's nickname comes from his being a 'Chip off the old block' because he looks just like his dad. Chipper was the Braves' first round draft-pick in the 1990 amateur draft and they haven't regretted it. He draws one of the highest salaries in the National League.

I have a great time with the Braves on the field and off. Here I am with 'Chipper' in Yankee Stadium after a game.

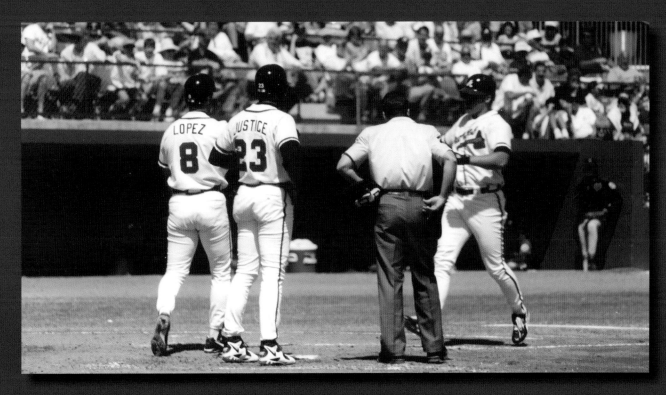

Despite the strike, the Braves stayed on course, focusing the next year on winning the Championship. In 1995, the team's unparalleled pitching was matched by a dynamic hitting foursome, Rookie of the Year Chipper Jones, Fred McGriff, Ryan Klesko, and David Justice.

Braves outfielder David Justice and catcher Javy Lopez greet hot dogger Ryan Klesko at home plate. Klesko was known to hit home runs, then have an immediate dugout chat with his batting coach. The media thought that was amusing and always followed and filmed him.

Braves catcher Javy Lopez was another 1995 standout.

The Braves are friendly and easy to get along with and Lopez was no exception. He hit like a power hitting outfielder and made the AllStar team numerous times.

Javy Lopez always had time for the fans. A native of Puerto Rico, he signed with the Braves in 1987, and left only because of the salary cap. In 2004 he signed with the Baltimore Orioles as a free agent. Lopez is an inspiration and is loved by young players looking for a role model.

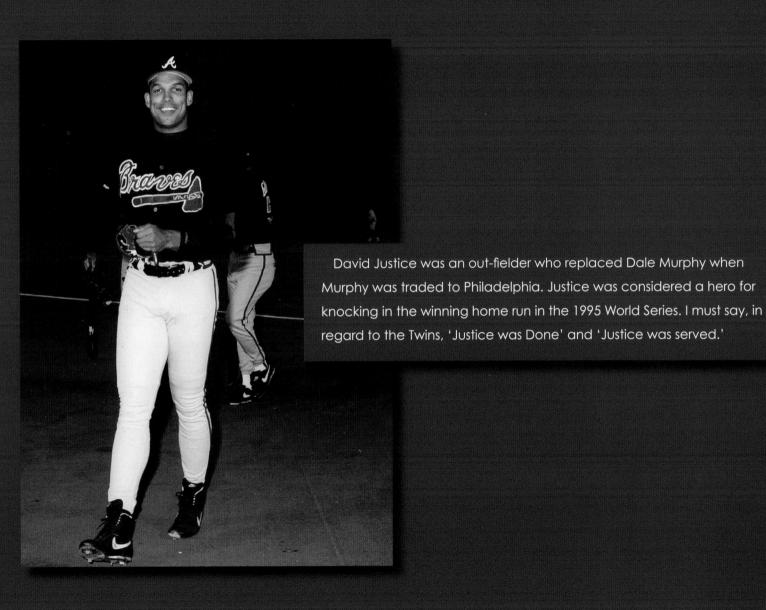

David Justice was an out-fielder who replaced Dale Murphy when Murphy was traded to Philadelphia. Justice was considered a hero for knocking in the winning home run in the 1995 World Series. I must say, in regard to the Twins, 'Justice was Done' and 'Justice was served.'

This celebration picture was taken October 29, 1995, at the end of the Braves' last game of the World Series in Atlanta-Fulton County Stadium. A copy is in the Hall of Fame.

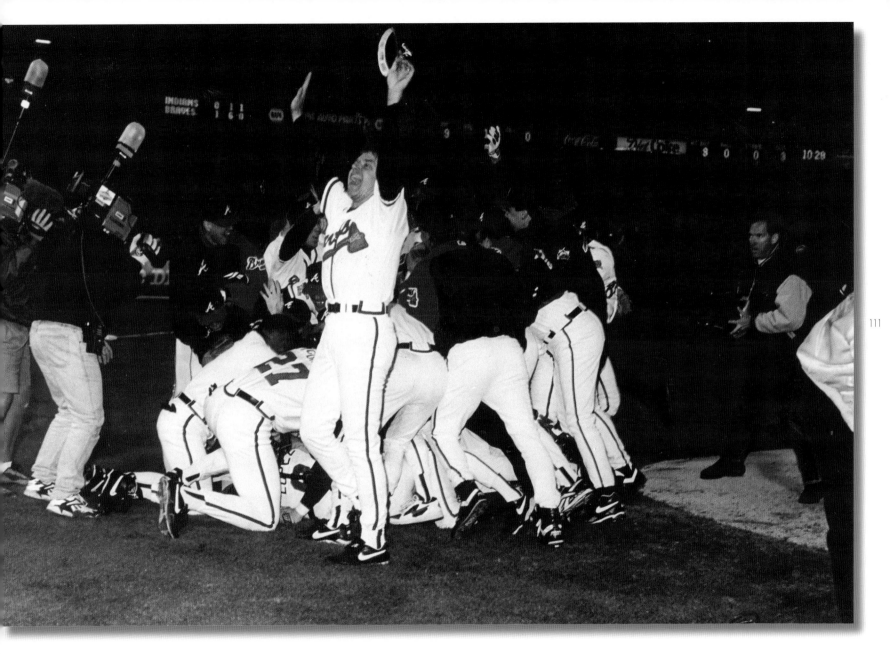

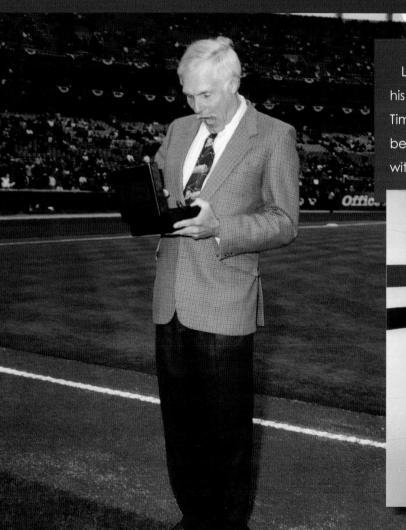

Look at the expression on Ted Turner's face as he gets his first look at his 1995 World Series Championship Ring. Times like this make me glad I have my camera. I've been able to share many special moments with people I admire.

Ted Turner pulls on his new 1995 World Series Championship tee shirt. The Braves defeated the Cleveland Indians for a series win and Turner was really proud.

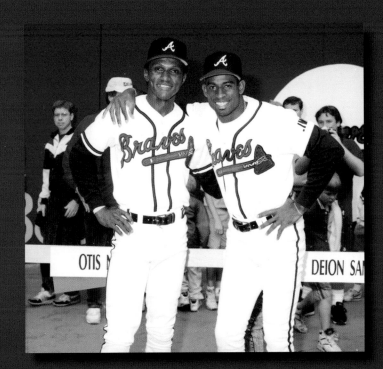

A switch-hitting out fielder, Otis Nixon, left, helped the Braves win the National League Championship in 1993. He and Deion Sanders, right, alternated playing center field.

On July 31, 1978, Pete Rose tied the National League record by hitting safely in his 44th straight game. One night later, the streak ended in Atlanta.

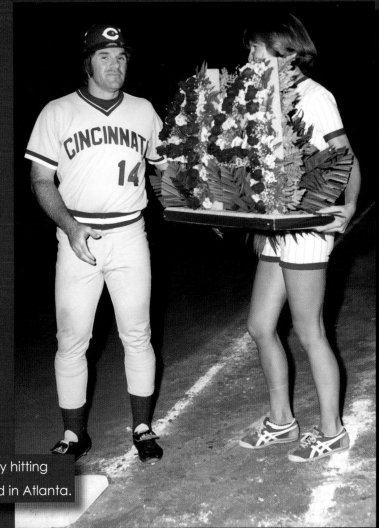

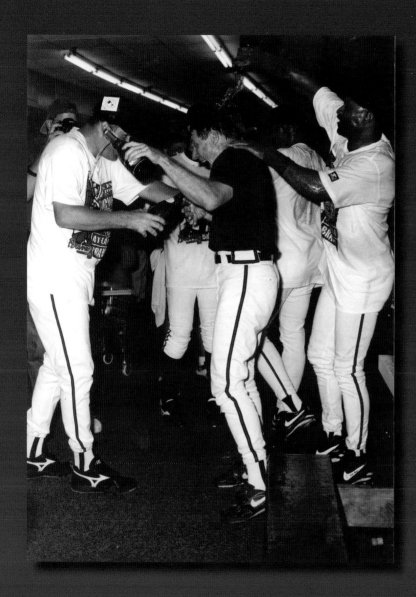

When the Braves celebrated their 1995 World Series victory, my camera got soaked with champagne. It had been through a lot so I guess it deserved it.

Ted Turner is a really nice guy. He told me to 'Just snap one picture' per subject. I wonder if he knew I had so many of him! Here we are together after the Braves won the World Series.

Parking decks in Atlanta overflowed as the 1995 World Series Champion Braves team rode past after defeating the Cleveland Indians.

The Braves are 1995 World Series Champions and everyone in Atlanta is proud. Look at all the people standing on the Fox Theatre Balcony.

CONGRATULATIONS BRAVES · 1995 WORLD SERIES CHAMPIONS

CONGRATULATIONS BRAVES
1995 WORLD SERIES CHAMPIONS

Thousands of Atlanta fans line Peachtree Street to greet the Braves during their 1995 World Series hometown victory parade.

New York Mayor Rudolph Giuliani grants an interview before a Braves-Yankees 1996 World Series game.

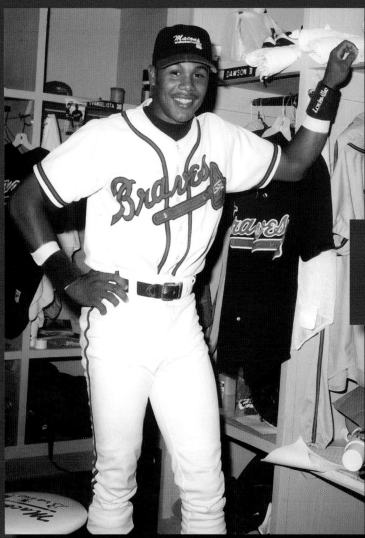

Andruw Jones has been compared to a young Mickey Mantle. I got this shot of him in Macon, Georgia, when he was a rookie.

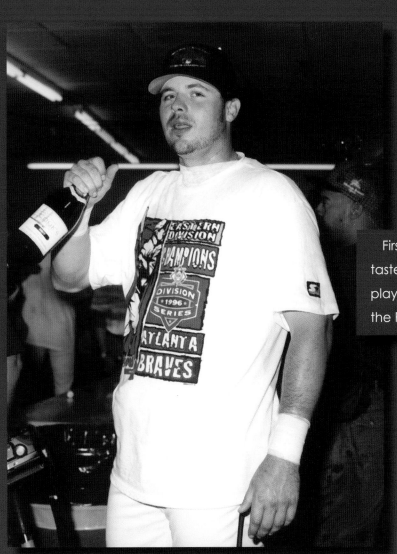

First baseman and outfielder Ryan Klesko is celebrating the sweet taste of winning the 1996 Eastern Division Championship. Klesko played for the Braves from 1992 until 1999 when he was traded to the Padres.

Greg Maddux, Chipper Jones, and Andruw Jones were three top Braves players, known for their consistency and their popularity with fans.

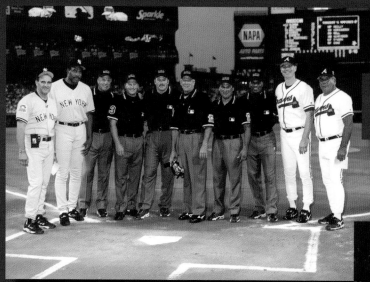

Yankees and Braves put aside their competitiveness and pose, with the umpires, for my camera before the game.

The Braves line up on the field before facing the Yankees in the 1996 World Series. It would be the last year the Braves played in Atlanta-Fulton County Stadium.

Bobby Cox and Joe Torre are shown at the Atlanta Braves versus the New York Yankees 1996 World Series at Atlanta-Fulton County Stadium. Joe 'The Godfather' Torre played with the Milwaukee Braves from 1960-1965 and came with them to Atlanta where he played from 1966-1968. In 1969, he was traded to the St. Louis Cardinals and in 1974 to the New York Mets. He played catcher and first base.

In 1977, Torre replaced Joe Frazier as the Mets' manager, then after being fired in 1981, he became manager of the Braves. He was fired by Ted Turner in 1984 and replaced by Eddie Haas.

Torre became manager of the Cardinals in 1990, and after being fired in 1995, accepted the position of Yankees' manager that same year. Torre is known for his 'hands off' managerial style. His brother, Frank, played for the Boston Braves, Milwaukee Braves, and the Phillies.

Ozzie 'The Wizard of Oz' Smith was one of the greatest defensive shortstops. He played for the Padres from 1978-1981 and for the Cardinals from 1982-1996. The Braves thought so highly of him they honored him with an autographed shirt, even though he played for the opposing team. He was inducted into the Hall of Fame in 2002.

Californian Ryan Klesco was known for his hitting when he was a Braves player. You could often count on him to hit a homer. He ended up playing for San Diego, not far from his home.

Everyone was shocked in 1997 as the Braves pitched, fielded, and homered into their sixth consecutive Division title. Although they didn't reach the World Series, fans and players had much to celebrate. It was the team's inaugural debut at Turner Field. The team stepped to the plate, winning twelve of their first thirteen home games. Team chemistry was manifested in Danny Neagle, Greg Maddux, Mark Wohlers, Tom Glavine, and John Smoltz. Smoltz was the first Atlanta Braves pitcher to have 200 strikeouts in four seasons. Chipper Jones, Ryan Klesko, Javy Lopez, Fred McGriff, and Jeff Blauser added punch power to the magic.

Blauser (shown) was always pulling tricks and making team members laugh with his off the wall comments.

Phil Niekro and Tommy Lasorda are inducted into the Baseball Hall of Fame in Cooperstown, New York in 1997. Lasorda, who claimed he 'bled Dodger blue,' was with the Dodgers forty-five years. His outstanding performance as a player, coach, scout, and manager was responsible for many of the team's achievements.

Turner Field is maintained by a top-notch ground crew. It's amazing how fast they can work. Atlanta-Fulton County Stadium was built in honor of the Braves coming to Atlanta. Turner Field began as the 1996 Olympic Stadium and was quickly converted to its long term purpose, a venue for Braves baseball. The grand opening was held on April 4, 1997. It is truly 'for the fans' and very upscale. Famous for its combination of technology and entertainment, its attributes include a fine sound system and spectacular BravesVision and PlazaVision video boards. There are over 500 television monitors placed throughout. The stadium, which has three levels supported by four concourses, has a seating capacity of over 50,000 and provides a breathtaking view of the Atlanta skyline.

I caught my co-worker Walter Banks's picture as he talked with Bill Espy, star of *Another World*. Banks has been an usher for the Braves so long he has his own 'suite.' He and I have the same first name and birth date—July 1. I consider him a close friend.

The Braves' seventh consecutive Division title, with 106 wins, came in 1998. Newcomer Kevin Millwood gave a stellar performance as did Andres Galarraga, Chipper Jones, Andruw Jones, John Smoltz, and Greg Maddux. Tom Glavine won his second Cy Young Award.

At left, Braves radio and television announcer Don Sutton. The former pitcher was inducted into the Baseball Hall of Fame in 1998 after playing for the Dodgers, Astros, Brewers, Athletics, and Angels. Known for his fastball and sweeping curveball, his performance was outstanding for more than two decades.

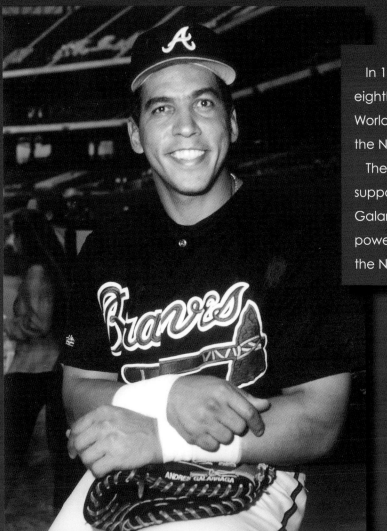

In 1999, the Braves won another National League pennant, their eighth straight Division title, and again faced the Yankees in the World Series. They lost against the Yankees but Chipper Jones won the NL MVP award and closer John Rocker made thirty-eight saves.

The Braves family rallied to give first baseman Andres Galarraga support when he was unable to play the season due to cancer. Galarraga (shown) was signed by the Braves in 1998 and was a powerful hitter and good first baseman. He is well-liked throughout the National League by players and fans.

Venezuelan Galarraga, called "The Big Cat," has a bright outlook on life, always smiling and upbeat. Shown here with his award-winning jersey, Galarraga was with the Braves from 1998 through 2000.

Yankee's manager Joe Torre is shown with Bob Watson, who played outfielder and first base in both the National and American Leagues. He was signed by the Houston Astros in 1965 and traded to the Boston Red Sox in 1979. That same year he was granted free agency and signed with the Yankees. In 1982 he was traded by the Yankees to the Braves, and played his final game with the Braves in 1984. He is now General Manager, Professional Baseball Operations.

Joe Dimaggio, the 'Yankee Clipper,' is shown at Yankee Stadium. Dimaggio could hit, throw, field, and run and was truly America's hero. A member of the New York Yankees from 1936-1942 and from 1946-1951, he played in ten World Series games and was considered one of the greatest baseball players to have lived. He was elected to the Hall of Fame in 1955. I was able to shake the great man's hand before his death in 1999 at age 84.

I had my camera ready
but the tables were turned.

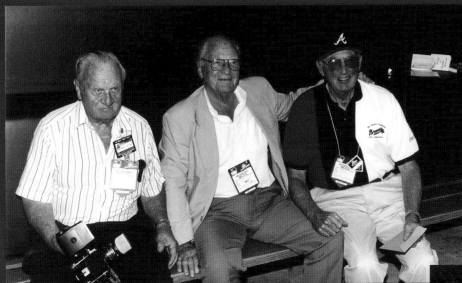

Here I am at Turner Field in the summer of 1999, with Sportswriter Furman Bisher and former pitcher and Braves announcer Ernie Johnson. Johnson was famous for his curveball and palm ball.

Sportswriter icon Furman Bisher attracts media attention. He writes for the *Atlanta Journal-Constitution* and is one of the most famous sportswriters in the southeast. Furman and I have been friends for years. In the right foreground are Ted Turner and Channel 5 sportscaster Jeff Hullinger.

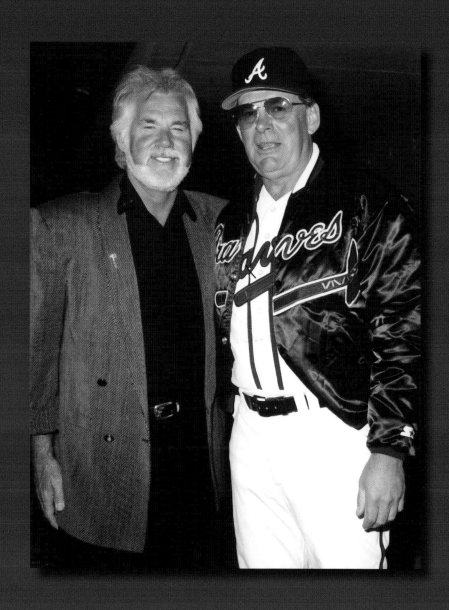

Braves fan Kenny Rogers enjoys a chat with Bobby Cox.

Here I am talking with Dugout Coach Pat Corrales at Turner Field. Corrales was a backup catcher to Johnny Bench for much of his career before becoming a manager for the Rangers, Phillies, and Indians. He's one of the many great people I've gotten to know while having such a good time with my camera.

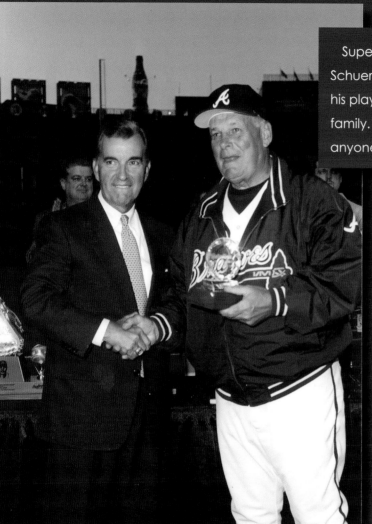

Super Manager Bobby Cox receives an award from John Schuerholz at Turner Field. Cox is a class act. He always stands behind his players and treats them as important members of the Braves family. He treats me well too, and I admire him more than anyone I know.

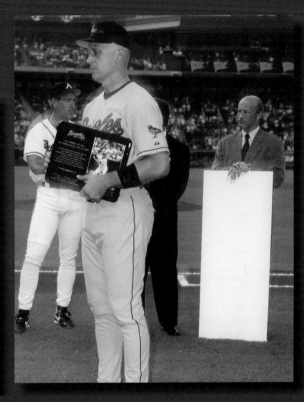

Baltimore Orioles player Cal Ripkin Jr. is honored by the Braves. Called the "Iron Man of Baseball," he played shortstop and was one of the game's greatest hitters.

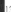

Ripkin and his father played for the same team, in different generations. A lot of people thought the Orioles had shown favoritism in hiring him, because his father, who was later manager, was third base coach at the time. Cal Jr. proved them wrong when he became 'Rookie of the Year.' His many achievements included two Gold Gloves, American League MVP, and leading the team to a championship.

Cal Ripkin Jr., with former President Jimmy Carter and his wife Rosalynn. Ripkin was known for his endurance and consistency.

You never have to tell Braves center fielder Andruw Jones to smile for a picture. Here he receives the Gold Glove Award at Turner Field. From Curacao, (off the coast of Venezuela), Andruw speaks five languages, and is the best center fielder in baseball. At nineteen, he was the youngest player to hit a World Series home run, and hit two in one night at Yankee Stadium.

The players like to pose with celebrities as much as fans do. Chipper Jones enjoys an on-field moment with Southern comedian Jeff Foxworthy.

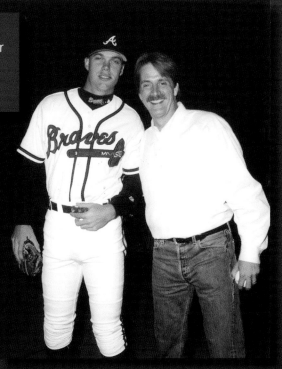

The Braves have always been appreciative of their fans and often interact with them. They are involved in many community activities and support many charities, raising hundreds of thousands of dollars for those in need.

Tom Glavine warms up for the mound, striking fear into opposing hitters. He was a member of the famous Braves' Glavine-Maddux-Smoltz pitching powerhouse.

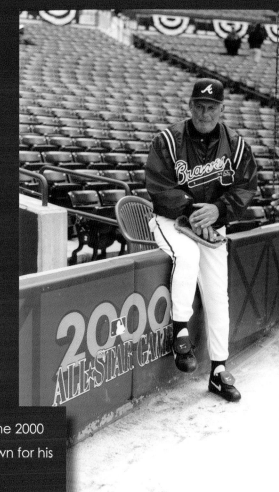

Here is Bobby Cox at the 2000 AllStar game. Cox is known for his compassion for players.

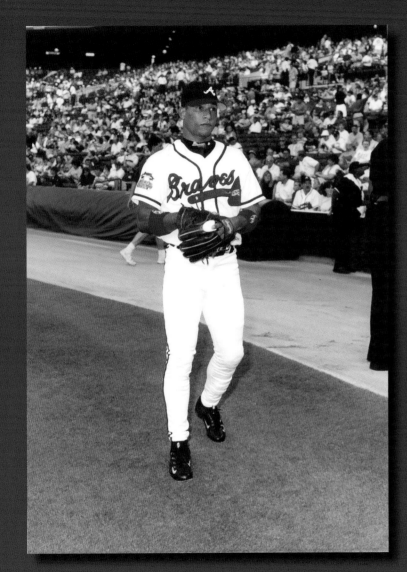

Although the Atlanta Braves won their ninth straight Division title in 2000, they were defeated in the Division Series by the Cardinals. Andres Galarraga was back after a successful bout against cancer, but pitcher John Smoltz was injured during spring training. Andruw Jones made the AllStar team and won the Gold Glove award for the third time. Other powerful performers included Chipper Jones, Tom Glavine, Greg Maddux, John Rocker, and newcomer Rafael Furcal.

An infielder, Rafael Furcal (pictured) has one of the best throwing arms in baseball and exceptional speed. His balls go by like rockets. Furcal, who came from the Dominican Republic, was signed by the Braves as a free agent in 1996. He came into the majors at age nineteen, and won the Rookie of the Year of Award in 2000. In December 2005, he became a free agent and signed with the Los Angeles Dodgers.

144

Braves Pitching Coach "Rocking Leo" Mazzone, far left, the late Dale Earnhardt of NASCAR fame, Bobby Cox, and car owner Richard Childress are caught in a rare moment in the Braves dugout. The legendary Mazzone is considered the best pitching coach in baseball. He is known to emphasize player health as well as strategy and tactics. During every game, he sits in the dugout, rocking back and forth.

Pitcher Tom Glavine and Earnhart paused for my camera in the Braves locker room.

Greg Olson, Braves catcher, 1990-1993, shares an umbrella with me during a golf outing. I always have my camera.

Jeff Francoeur was a first round draft choice in 2002, and has proved to be a great right fielder for the Braves.

Macon, Georgia native John Rocker strikes a pose for my camera. Rocker was drafted by the Braves in 1993. In 2001, he was traded to the Cleveland Indians and then to the Texas Rangers. In 2003, he played briefly for the Tampa Bay Devil Rays. Although he was known for making controversial comments, I've always liked him.

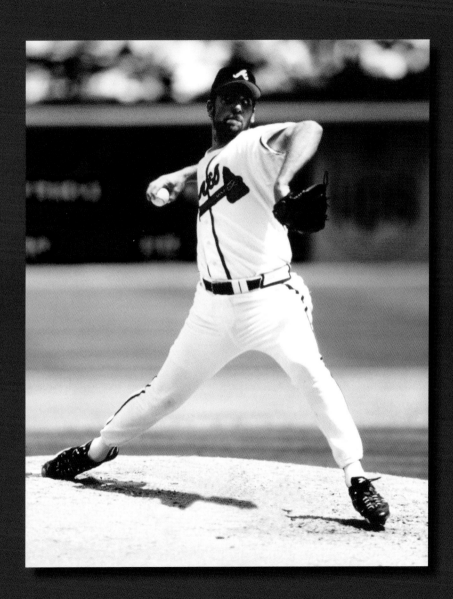

Here is my friend John Smoltz at Turner Field. He is one of the Braves' most talented pitchers and has repeatedly been named to the League's Allstar team. He's also an outstanding golfer, and excels in other sports too. Smoltz has been a role model for many young children who grew up to play in the big leagues. One of them is Braves pitcher, Kyle Davies.

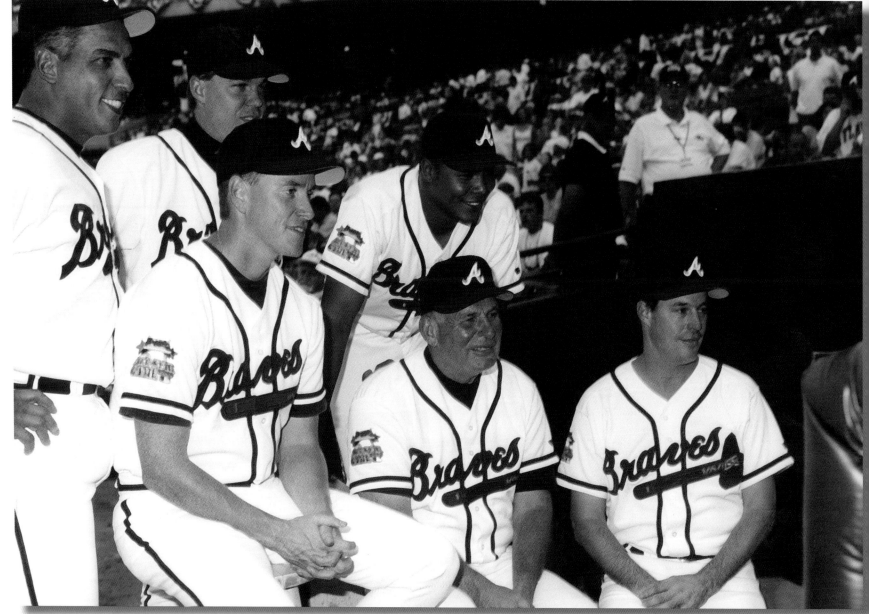

The year 2001 was an emotional time for everyone with the events of September 11. After the terrorist attack, baseball temporarily came to a halt, then resumed in a flurry of patriotic displays. The remaining games seemed to give the American people a sense of continuity. The Braves won their tenth division title and both Greg Maddux and Andruw Jones were awarded Gold Gloves. Chipper Jones and Tom Glavine were also standouts.

Something really caught their attention! (Left to Right-Andres Galarraga, Chipper Jones, Tom Glavine, Andruw Jones, Bobby Cox, and Greg Maddux)

John Smoltz, Andruw Jones, and Tom Glavine made a power-packed threesome on Turner Field.

Meeting and photographing celebrities is a lot of fun. In 2001, I got in the picture with Georgia's own country singer, Tricia Yearwood.

Hank Aaron and Tom Glavine are two of baseball's finest players. Here, they are shown walking off the field. Aaron still lives in the Atlanta area where he owns car dealerships, but he still takes time for baseball appearances.

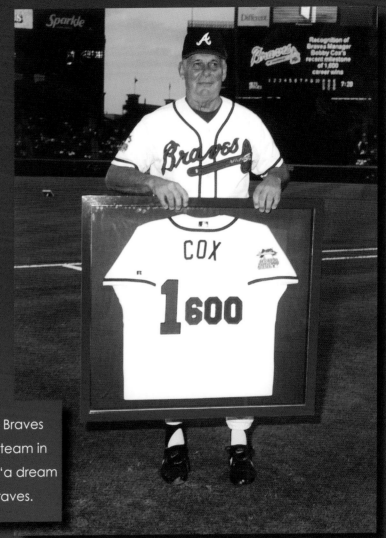

Bobby Cox displays his Braves jersey representing 1600 wins. The Braves have won more games in the past fourteen years than any other team in baseball. For Cox, involvement in professional baseball has been 'a dream come true.' His involvement is also 'a dream come true' for the Braves.

Dusty Baker, manager of the San Francisco Giants, is shown here with Bobby Cox. Baker was an outfielder who played both for and against the Braves. Known for his speed and hitting power, he was drafted by the Braves in 1967, and was traded to the Los Angeles Dodgers in 1975 where he was the National League Championship Series MVP in 1977.

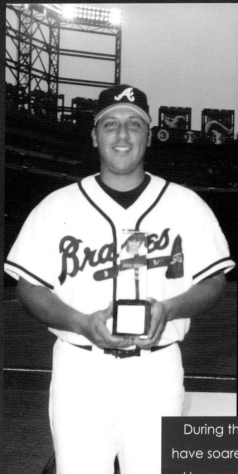

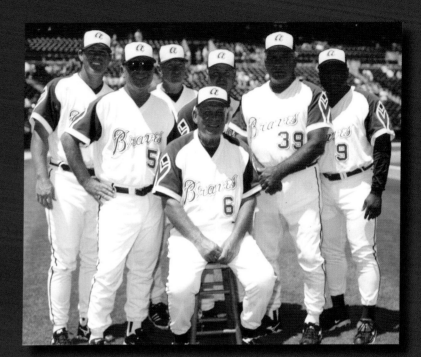

Atlanta Braves manager Bobby Cox, seated, is surrounded by his renowned coaching staff.

During the 21st century fans are seeing baseball salaries soar as high as the homers. The Braves have soared too, continuing to earn division titles. Bobby Cox has recorded his 2000th victory.

I love watching the players as they develop. In 2002, Russ Ortiz, left, came to us from the San Francisco Giants, where he'd played since being drafted in 1995.

Chuck Dowdle, of Channel 2's Action News, is a familiar
face at Turner Field and frequently interviews players.

The Braves went on to another Division title in 2003. I got this shot of Greg Maddux
after an unprecedented pitching performance. The team works hard to do a
good job and their scores show it. Greg 'The Professor' Maddux was drafted by the
Chicago Cubs in 1984 and played with them until 1992 when he signed with the
Braves. He led the Braves through a decade of postseason playoffs and won four
straight Cy Young Awards before returning to Chicago in 2004.

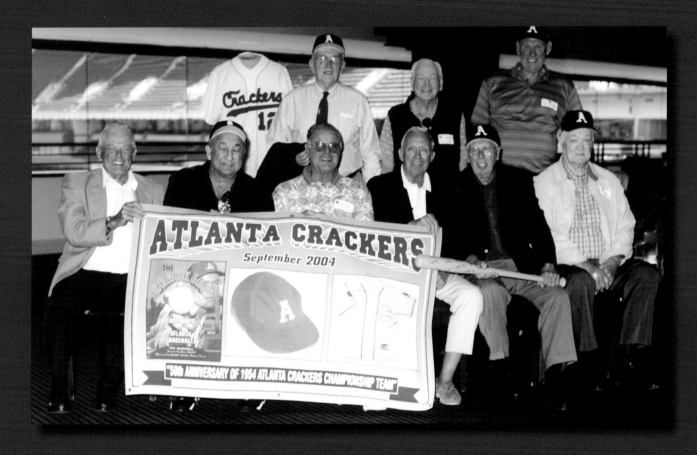

The year 2004 was marked by many special events. This picture was taken at the Atlanta Crackers Championship Team Reunion in September 2004. Both the Atlanta Crackers and the Atlanta Black Crackers, which were organized in 1919 and played through the late 1940s, were well-known and highly respected early Georgia ball teams.

The Braves Dugout gets really intense when game scores are close.

Bobby Cox, Leo Mazzone, and other team members view the game from the dugout. If you looked closely during a game, you'd see Mazzone rocking.

Bobby Cox is in deep conversation with New York Yankees pitching coach, Mel Stottlemyre.

John Smoltz and I are caught by a camera. I consider him and all the players to be my friends.

The year 2005 was the 'Year of the Rookies.' The Braves were plagued with injuries but thanks to our fantastic farm system, set up by Lucas, the team was prepared. The newcomers added interest and excellence, and made a fantastic season save.

Before a game, Bobby Cox relaxes in his cubbyhole with a handmade cigar. Hired by Ted Turner as Braves Team Manager in 1978, Cox was fired after the 1981 season. A series of successors followed, including Joe Torre. In 1986, Turner rehired Cox as General Manager, a position later changed to Manager. Cox patterns his managerial style after Yankees manager Ralph Hauk, crediting him with being an example of leadership and caring. Cox claims he has never had a bad day in baseball.

Hooray for the 2005 rookies. Here are some of the 'Baby Braves.' Their excellent performance was a god-send when so many Braves players were injured. I enjoyed meeting them all and will watch them through the years.

Brian Jordan came out of college to play football for the Atlanta Falcons. He was a very good defensive safety, playing in the backfield with Deion Sanders. If he had stayed in football he'd have probably been all-pro in a year or two, but he had been playing minor league baseball and, in 1988, he signed a contract with the St. Louis Cardinals. When he had to choose between football and baseball, he chose the latter because of the money, working quickly through the Cardinals system. He came to Atlanta as a free agent in 1998. In 2002, he was traded to the Dodgers, then later, went with the Texas Rangers. Jordan came back to the Braves in 2005 and I was glad to see him.

a little something extra

Quarterback Steve Young played for Tampa Bay and the San Francisco 49ers. Young was an excellent runner, a left-handed passer, and very hard to tackle. A descendant of Brigham Young, he attended Brigham Young University before turning professional. He is a two-time league MVP and is in the Football Hall of Fame. I took this shot when he was playing with San Francisco against the Falcons. A devoted family man, and occasional TV analyst, Young is founder of the Forever Young Foundation, raising large sums of money to aid youth organizations and other charities throughout the West.

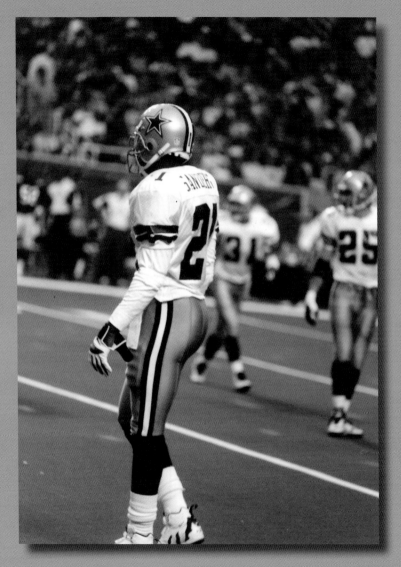

I shot this when Former Falcon and 49ers' cornerback Deion Sanders played for the Dallas Cowboys. The number one NFL draft choice from Florida State played pro football as well as baseball. Sanders was multi-talented and performed as a punt and kickoff returner on special teams, as well as a wide receiver. He retired, only to soon return and play for the Baltimore Ravens. His football stats show him to be one of the greatest cornerbacks of his time in pass coverage. When he'd come on field, the fans would go wild. Sanders played for the Falcons from 1989-1993, was1994 AP Defensive Player of the Year while on the roster for the San Francisco 49ers, and played for the Cowboys from 1995-1999. He played for the Washington Redskins in 2000. He was nicknamed 'Prime Time' because TV cameras were constantly on him.

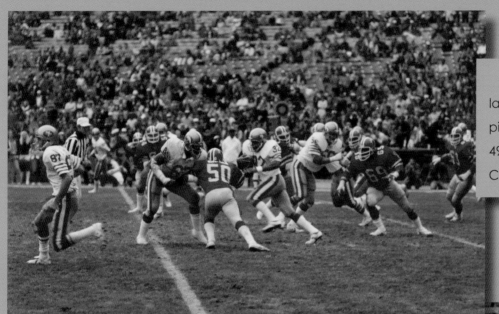

I was lucky to get this shot of O.J. Simpson's last run in 1979. It is one of my most popular pictures. O.J. was playing for the San Francisco 49ers against the Falcons in Atlanta-Fulton County Stadium and is wearing jersey #32.

The Falcons finally tackled Simpson, one of the greatest running backs in history, on the twenty-yard line, and the moment was captured on my film for National Football League history.

Photographing the Falcons Cheerleaders was an especially nice part of my job.

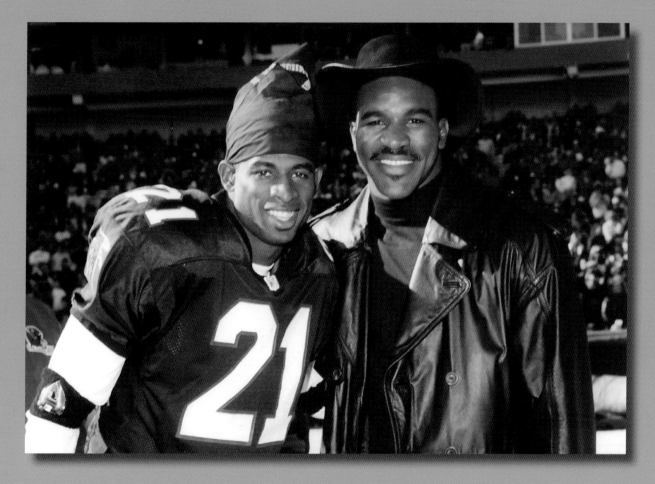

Deion Sanders, one of the greatest baseball and football celebrities of all time, talks with Evander Holyfield, one of the world's greatest boxers.

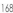

Once while photographing a Falcons game, I was run over by Falcons' running back Tony Jones. I recovered, and resumed my work, but Jones, who had been a top draft pick, limped off the field.

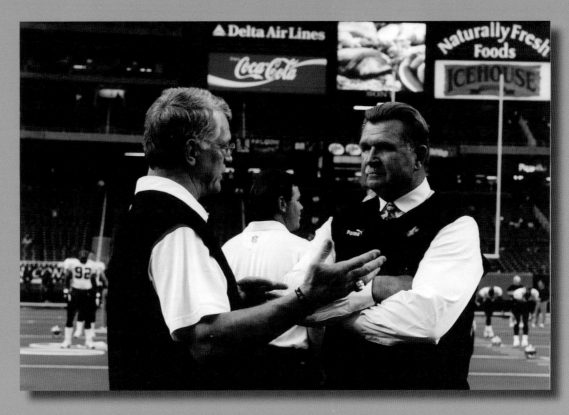

Falcons Coach Dan Reeves is shown with New Orleans Saints Coach Mike Ditka. Reeves replaced June Jones as the Falcons head coach in 1997 and led the franchise to its first Super Bowl appearance. Reeves was 1998 NFL Coach of the Year and continued as Falcons' coach into 2003. Although they coached opposing teams, Reeves and Ditka have a close friendship which began when they were teammates for Coach Tom Landers' Dallas Cowboys. They were also fierce competitors on the racquetball court.

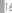

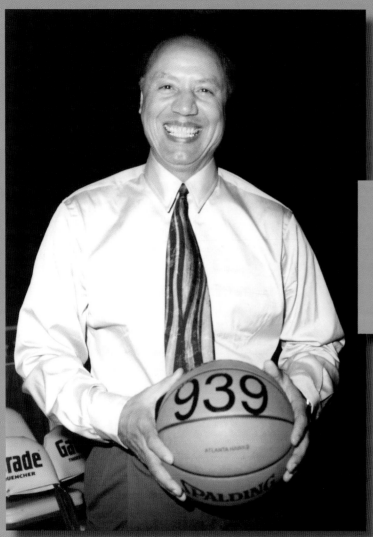

Lenny Wilkins came to Atlanta in 1993 and coached the Hawks until 2000. Coach of the Year in 1994, he was inducted into the Basketball Hall of Fame as both player and coach.

This lucky shot catches Michael Jordan in mid-leap when the Chicago Bulls were in town for a game with the Hawks.

Michael Jordan takes a shot against the Hawks, wearing a number 45 jersey (he usually wore number 23).

Dale Earnhardt makes his last run around the Atlanta Motor Speedway track. Following in his father Ralph's footsteps, Earnhardt was one of the most outstanding NASCAR drivers in motorsports history. He died on February 18, 2001.

His memory is kept alive by his fans, who refer to him as "Forever the Man."

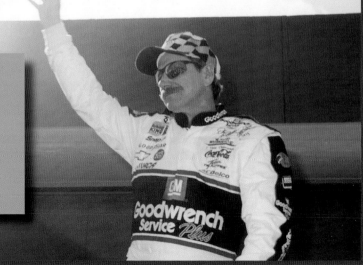

The last time Dale 'The Intimidator' Earnhardt was at Atlanta Motor Speedway, he waved to the crowd for this picture. I had no way of knowing it would be one of the last ones taken there. He was killed several months afterward on the last lap of the Daytona 500.

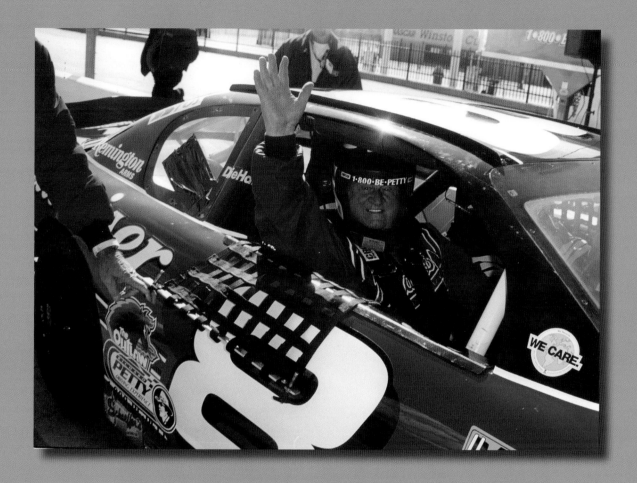

I'm in my nineties, but my life is fast-paced. Here I am in a Petty Experience racecar at Atlanta Motor Speedway in Hampton, Georgia. The car reached 165 miles per hour, and I was glad to live to tell about it.

Falcons' linebacker Jessie "The Hammer" Tuggle was raised in Griffin, Georgia, and joined the Falcons in 1987 after playing for Valdosta State. He stayed with the team until 2000.

I've known Walter Victor for 28 years. I look forward to seeing him as soon as I hit the dugout coming out of the Clubhouse. Walter brightens up our day because he's always smiling and he's always nice. What he has done stays in the back of our minds, not only what he has done for the Braves but for his country. Walter is one of the nicest and hardest working gentlemen I've ever met and if I were in the military I'd want Walter in my unit; That's for sure.

Bobby Cox
Atlanta Braves Manager
2005